THE GARDENS
OF FLORIDA

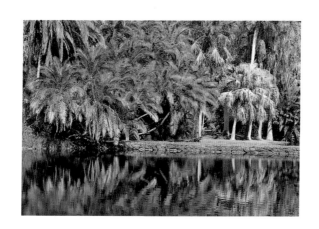

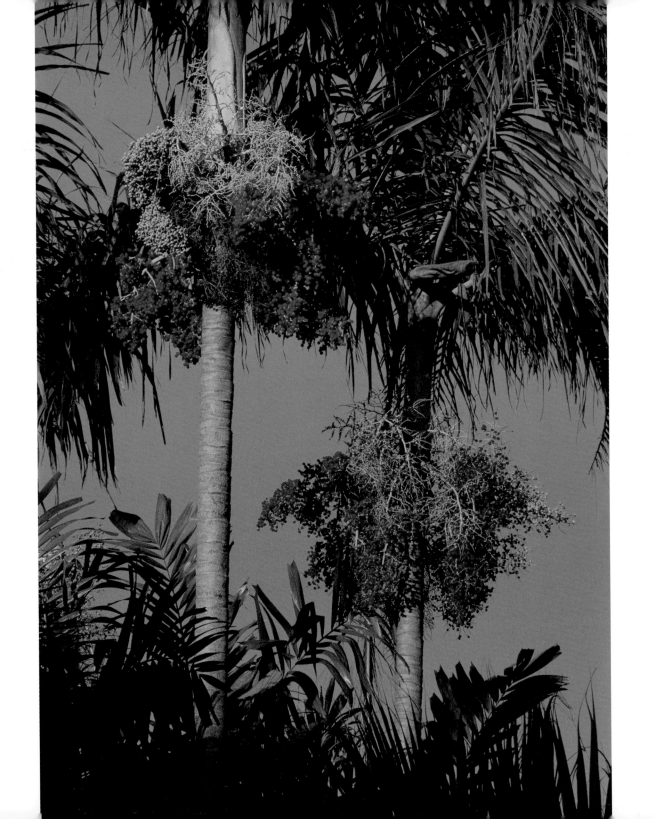

THE GARDENS OF FLORIDA

By Steven Brooke and Laura Cerwinske

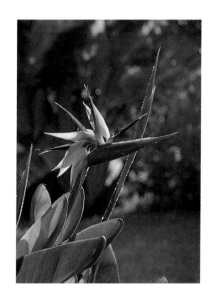

PELICAN PUBLISHING COMPANY

Gretna 1998

*The word "Pelican" and the depiction of a pelican are trademarks
of Pelican Publishing Company, Inc.,
and are registered in the U.S. Patent and Trademark Office.*

Library of Congress Cataloging-in-Publication Data

Brooke, Steven.
 The gardens of Florida / by Steven Brooke and Laura Cerwinske.
 p. cm.
 ISBN 1-56554-184-7 (hc. : alk. paper). — ISBN 1-56554-179-0 (pbk. :
alk. paper)
 1. Gardens—Florida. 2. Gardens—Florida—Pictorial works.
I. Cerwinske, Laura. II. Title.
SB466.U65F63 1997
712'.5'09759—dc21 97-85
 CIP

Front and back cover: Cypress Gardens, Winter Haven

Photo on p. 1: Fairchild Tropical Garden, Miami
Photo on p. 2: Fairchild Tropical Garden, Miami
Photo on p. 3: Bird of paradise
Photo on p. 6: Passion vine

Printed in Hong Kong
Published by Pelican Publishing Company, Inc.
1101 Monroe Street, Gretna, Louisiana 70053

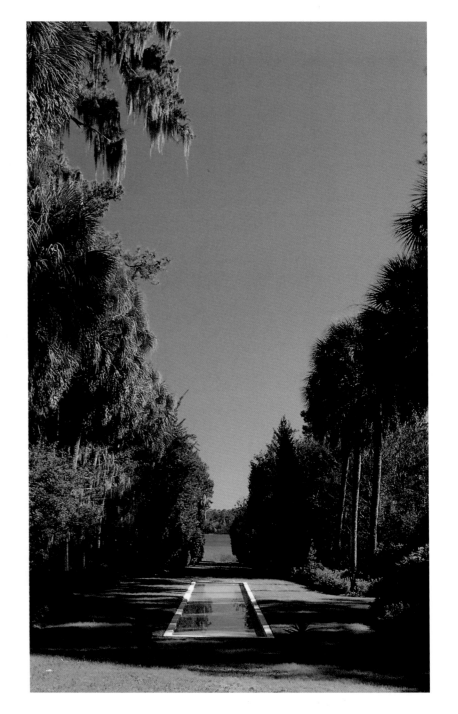

For Suzanne and Miles
and in memory of Allan Fernandez
—SB

In memory of Aunt Barbara
who cultivated her garden
and in tribute to Michael Crawford
who tends mine
—LC

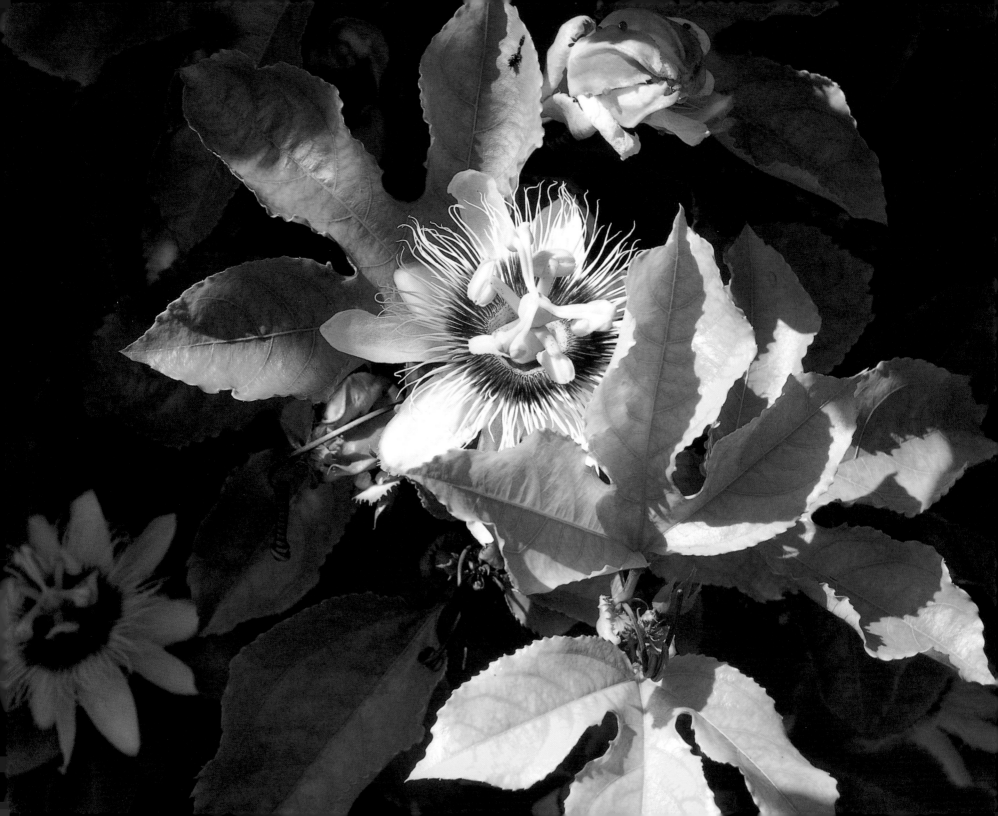

CONTENTS

INTRODUCTION

If the 16th century Spanish explorer Ponce de Leon had first stepped onto Florida's shores as we know them today, he would have found himself surrounded by a jungle of color, fragrance, and plants of such mythological proportion that he would have believed he had discovered not simply the land of the Fountain of Youth . . . but Eden itself: tall palms and taller pines flourishing in brilliant sunlight, canopies of vivid petals, aromatic blossoms, fantastically shaped leaves, monumental stalks, flower-laden branches, and at every turn, another wonder offering up its fruit, its shade, its sheer beauty.

The pine scrubland that Ponce de Leon actually discovered, though yet to acquire this botanical luxuriance, bore a more primitive beauty—a kinetic tranquillity punctuated by the piercing drone of cicadas and scented with moldering pine straw. This decay produced an excellent top soil which enhanced the growth of the tall native slash pines, saw palmettos, and sabal palms. In the centuries to come, more exotic species of plant life would make their appearance on this Florida landscape, some a result of sheer accident—such as the first palms that blew ashore from a shipwreck off the coast of what would become Palm Beach—and some the product of deliberate cultivation. The lush density of Miami's Coconut Grove, for example, was nurtured by that community's Caribbean settlers in the 1800s who arrived from their islands "with pockets full of seeds."

Few useful and edible plants grew in the limestone soil of the Florida Keys when the first European settlers arrived there in the early 1800s. By the time John James Audubon visited Key West in 1832, however, that tiny pioneer town was already bustling with the commerce and activity stimulated by its population of

AT LEFT:
The garden at Audubon House, Key West.

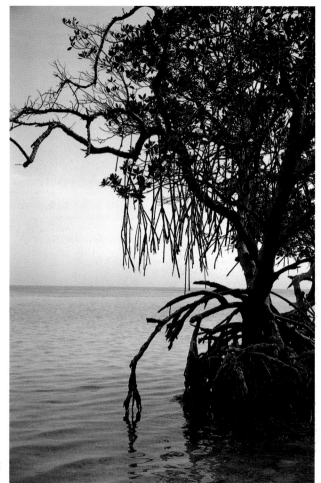

Mangroves at Matheson Hammock Park, Miami.

southern businessmen, European traders, shipwreck survivors, and adventure seekers from all over the world—England, Holland, Russia, Italy, Spain, Cuba, Canada, Scotland, France, and the East Indies. Many brought with them their knowledge of the functional and decorative gardens of their native countries.

The first Key West gardens, naturally, were practical food-growing and shade-producing endeavors. Native plants such as sea grape and coco plum were cultivated, along with such newly introduced edible exotics as bananas, coconuts, limes, and tamarinds; ornamental exotics such as bougainvillea, lantana,

and bromeliads; and medicinal plants. Mariners and botanists continued adding to these lists throughout the nineteenth century. An excellent example of the typical 19th century Key West garden is the Audubon House and Tropical Gardens which were first restored by the Mitchell Wolfson Family Foundation in 1959.

Further north, in Port Orange, near Daytona Beach, Sugar Mills Garden offers a look at the plants—such as sugarcane, coontie (the root of which was ground into starch and used for bread and other purposes), and gingerroot—which Florida's east coast pioneer settlers cultivated to survive off the land. The garden also features crinum lily, which was planted for ornamental purposes. (This public garden, once a 1930s amusement park called Bingo Land, also exhibits over 100 species of ivy.) In northwestern Florida, the early gardens planted Indian pumpkin, corn, beans, and other crops that could be cultivated easily in that region's red and yellow clay soils.

Gray and black flatwoods soils constitute the makeup of the earth on the northeastern part and in much of the center of the state; in many parts of the central eastern and southern regions,

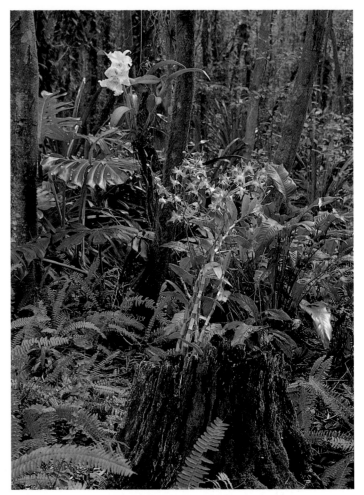

Dendrobium orchids growing in the wild.

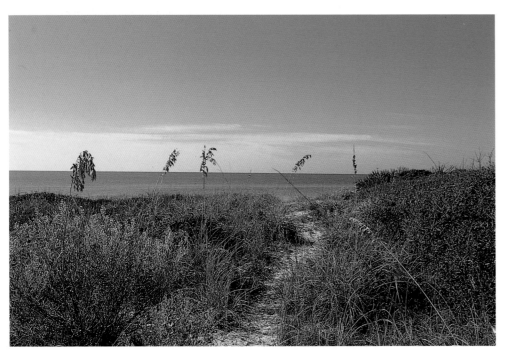

it is gray and black flatwoods over lime materials. Muck and peat soil predominate in inland pockets of southeastern Florida, while swamps, scrub, or dry sand are found in the state's western lower tip. The soil of the Redland—the state's largest crop growing area and the lime capital of the country—is, remarkably, so rock hard that it must be "scarified" or dug up with an auger for planting.

This wide variation in the qualities of Florida's soil contributes to an equally wide variety of microclimates which, in

Beach dunes and sea oaks along the Panhandle at Seaside.

turn, produce a wide variety of horticultural "communities": coastal dunes, hammocks, fresh water swamps or wetlands, salt water wetlands, sand pine scrub, dry pine land, and pond and river margins. Each type of "community" serves as sanctuary to a specific list of plants and fauna, most of which are native to tropical and subtropical climates.

The tropics, in strictly geographic terms, lie between the Tropic of Cancer and the Tropic of Capricorn, making Hawaii the only part of the U.S. to fall within the region's literal definition. The subtropics (or semitropics, as they are also called) are the regions of warm, moist climate extending 300 to 700 miles to the borders of the temperate zone. Southern Florida is subtropical; central and northern Florida are more temperate.

The tropical climate fosters the growth of dense tangles of seemingly impenetrable vegetation, on a gigantic scale. In fact, the tropics are home to the greatest concentration and variety of plant life on earth—more than 200,000 species. Because there is little or no frost to restrict growth or kill off sensitive plants, many tropical, warmth-loving species are well adapted to subtropical conditions, especially palms, cycads, aroids, cacti and succulents, and ferns. Some, such as epiphytes, grow prolifically on other—host—plants.

The flamboyant color, size, fragrance, and shape of tropical plant life evolved out of the botanical competition to attract pollinators and capture available light. From fruit and flower to palm and pine, from vine and shrub to aroid and succulent, and from native plant to rare import, the gardens of Florida possess a greater variety of botanical species, scents, and design styles than any other region of the continental United States. In winter, while camellias are blooming in the Panhandle, grapefruits, oranges, and limes are hanging heavy on trees from north of Orlando to south of Miami. In spring, while gardeners in the

A stand of maleleucas at Deep Lake.

A laden coconut palm.

Bromeliads in bloom.

Jackfruit.

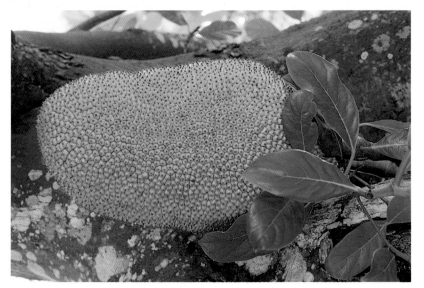

Jackfruit.

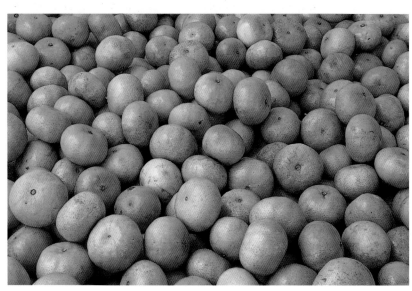

Florida oranges.

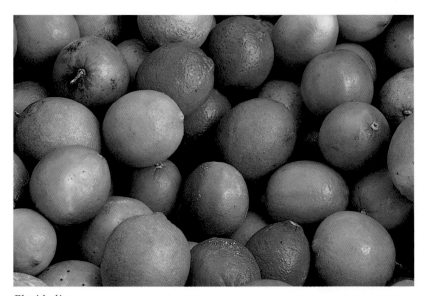

Florida limes.

northern and western U.S. are sowing their annuals, southern Floridians are breathing in the gardenia-scented air as they tend the mango and early avocado blooms and watch certain species of bamboo grow as much as a foot a day.

Southern Florida's farmers have not one, but *two* growing seasons (summer *and* winter). In fall, while the rest of the country begins to harvest its vegetables and turn the ground under for its long winter's rest, Florida crop growers are preparing the soil for seeds and seedlings. On the south and east side of Lake Okeechobee, rich muck land deposits and winter winds tempered by the warm lake waters contribute to an extended growing season. On the lower coasts, the warm waters of the Gulf Stream and the balmy trade winds create the same effect, making

A Barbados cherry.

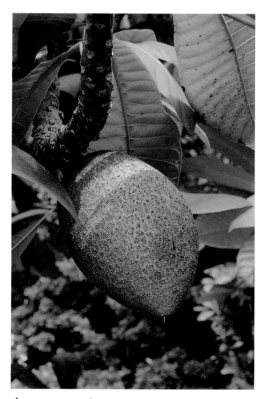

A mamey sapote.

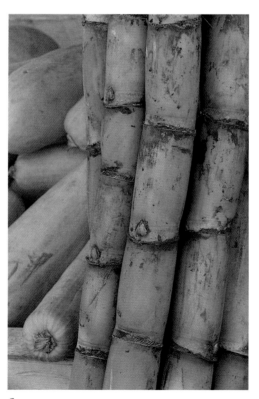

Sugarcane.

southern Florida the only subtropical farming area in the continental U.S., and, not surprisingly, the winter vegetable capital of the nation.

The state is blessed with not only two growing seasons, but also exceptional fecundity. The potted ficus used as houseplant elsewhere becomes a sprawling forty-foot-high tree here. One factor that accounts for this intensity is Florida's unbroken horizon, across which the sun pours without the interruption of a forest canopy or mountain contour. The flatter the landscape and the broader the vista, the more difficult a horizon is to punctuate. In Florida, trees must provide not only shade, but also the undulation that geographic formations such as rolling hills provide elsewhere.

Verticality, therefore, is a critical feature in the design of Florida gardens. Such sky-reaching trees as royal palms dramatically punctuate the horizon and add definition to the long vista. When planted in the linear compositions to which they are so well suited, these majestic trees are best sited at the perimeter of the garden where

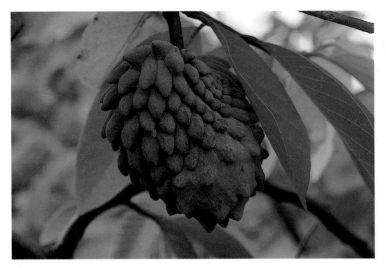

An annona.

they will not grow in conflict with the canopy.

Gumbo limbos and other native hardwoods, such as mahogany and live oaks, serve to create a beautifully textured canopy. Plants selected to grow beneath it must be those, such as shade-loving palms, that won't reach for the sky. Chinese fan palms, for example, look compatible until they reach eight feet in height; once they grow taller, however, their fronds physically—and visually—penetrate the canopy, disturbing both the growth pattern and look of the garden.

In the tropics and subtropics, air movement is comfort. Thus, the final critical consideration in the design of Florida's gardens is the region's high humidity. Plants must be selected for their ability to allow for the penetration and circulation of breezes. Stalkier plants, such as ginger and heliconia, and airy, frond-bearing trees such as palms are classic examples.

My own love of Florida's botany was engendered early in childhood. Our family house in Miami was situated next door to a small (fifty-by-one-hundred-foot) wooded lot in which palmetto scrub, mother-in-law-tongue trees, and a host of native vines grew totally undisturbed and untended. While the other little girls on the block played with their dolls and attended Girl Scout meetings, I was busy climbing trees, building tree houses, hacking paths through the scrub and shrubs, and playing Sheena Queen of the Jungle. As a shy, brown-limbed, barefooted tomboy, those woods were my sanctuary, my solace, my Eden. A decade later, as an introverted academic who had just finished her junior year of college studying art history in Italy, I took to travel in my search for the door to the meaning of life. On my own and with limited funds, I decided to go work on a kibbutz in Israel.

Kibbutz Tzorah was, in 1968, twenty years old like me. But while I was still haltingly transcending adolescence, Tzorah was a determinedly unselfconscious organism with a clear mission—to be fruitful and survive. Quiet and purposeful, it looked like a cross between an adult summer camp (with its residents and volunteers all dressed in standard-issue shorts, sandals, and workshirts) and a lovingly landscaped army camp, with half-grown trees and fragrant shrubs shading paths that led through the community of rudimentary buildings. Grape vineyards covered the hills behind it. Orchards stretched as far as the eye could follow. The scent of roses and oleander perfumed the hot, dry breezes. It was serene and self-possessed; it was everything I needed.

I spent my days working in the peach, plum, and persimmon

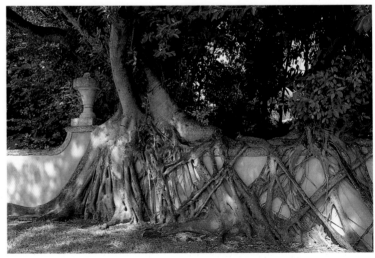

Banyan roots overtake a garden wall.

14

Detail of a croton leaf.

Detail of an antherium leaf.

orchards—fertilizing, irrigating, pruning, and picking. I loved the slippery balm of mud up and down my legs, the toasting of my shoulders from the sun, the smell of dirt, and the discovery of buds on young branches. I hauled irrigation pipes, pruned trees, tended grafts, and watched branches go from flower to fruit. Savoring the dark deliciousness of a ripe persimmon grown in *my* orchard, I exulted in my small part of the fruit's cultivation.

The magic of kibbutz life remained with me over the next ten years while I finished college, traveled more across the U.S. and Europe, started my writing career in New York, and returned to Miami where I married. During a trip to north central Florida, my then-husband and I visited my friend Patti Jacobs, who was fulfilling her own lifelong dream by homesteading an eighty-acre parcel of pinewood and meadow near Ocala she had named Sparrowhawk Farm. We talked of stewardship of the land and of the possibilities of a cooperative life there in the pinewoods. The

echo of Sheena and the pentimento of Tzorah obliterated all doubt. This would be the place to raise my infant son.

For Patti the dream prevailed. For me, even the rudimentary stage of the endeavor overwhelmed. My son and I returned to Miami, then to New York and an urban life of travel and intense productivity, haunted from time to time by the memory of the smell of pine straw moldering in summer heat and the sly cast of sunlight across a palm leaf in winter.

I was 42 years old when I returned to Miami and bought my

first house. Although I had established my career as an architecture and interior design writer, I was lured not by the house, but by its sprawling, "Old Florida"-like garden: an acre of live oaks, black olives, citrus trees, bromeliads, heliconia, and some of the last remaining high pines in Dade County. An expanse of green lawn, a secret garden, and the mystique of a tucked-away woods: Sheena would be happy here. And Kibbutz Laura would find no end to her lust for cultivation.

My delight turned to despair as I realized the measure of energy and resources required to keep up with my garden's basic maintenance, let alone with implementing ideas, plans, and designs. Yet, slowly, the inspirations are taking root. After I saw the Marcello Mastroiani film *Dark Eyes*, set in the spa at Montecatini with an outdoor rotunda of tall columns, I decided I *had* to have a rotunda—only mine would be of palms. The big grassy lawn where we picnic and play baseball has been left intact, despite my appreciation of the more prudent, water-saving, and ecologically responsible approach of xeriscaping. After all, I think of the lawn as my homage to the great American landscape architect Frederick Law Olmstead, whose Central Park, with *its* Great Lawn, provided me countless hours of spiritual nourishment during my days in New York. Olmstead's influence, in fact, has its precedence in Florida at Fairchild Tropical Garden, which was designed by William Lyman Phillips, one of Olmstead's associates, and Bok Tower Sanctuary, which was designed by his son.

As I have experienced all my life, Florida gardens, with their exaggerated appeal to the senses, are a perpetual seduction. The more romantic of the early Europeans who first came to our shores were entranced by the exotic plant life around them. The less adventurous felt ill at ease, sensing something immoral and undisciplined in all this riotous growth. Since the state's first public garden—Cypress Gardens—opened in 1936, millions of the romantic, adventurous, and simply curious have had the privilege of indulging in our botanical luxuriance. The creators of Florida's public wonderlands, all of which were conceived and developed during the twentieth century, range from brilliant promoters to horticultural visionaries to passionate philanthropists. Dick Pope of Cypress Gardens, Franz Scherr of Parrot Jungle, "Jungle Larry" and "Safari Jane" Tezlaff of Caribbean Gardens, and George Merrick of Coral Gables understood the commercial appeal of the state's flamboyant botany. Thomas Edison, David Fairchild, Floyd and Jane Wray, Dr. Henry Nehrling, and Marvin Mounts were devoted to botanical exploration and cultivation. Marie Selby, Harry P. and Mary Jane Leu, James Deering, Edward M. Bok, George Sukeji Morikami, Frederic and Evelyn Bartlett, Alfred B. and Louise Maclay, and Nina May Cummer were passionate gardeners and lovers of beauty.

The gardens of Florida, whose history and photographs comprise these pages, are their legacy.

LAURA CERWINSKE

*Begonias in a
Coconut Grove garden.*

16

THE GARDENS
OF FLORIDA

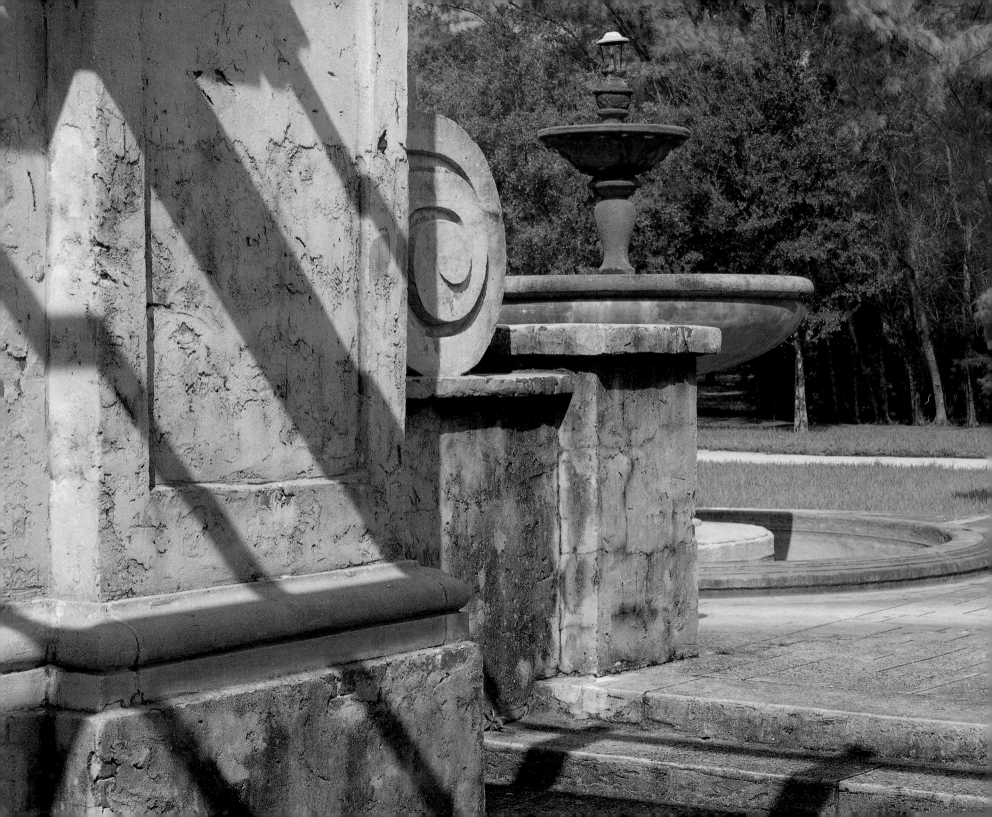

CORAL GABLES

The Mediterreanean-style City as Garden

Much of the most memorable character of southern Florida's landscape architecture derives from the picturesque Mediterranean tradition. Promoted by the region's Spanish colonial heritage, such features as thick masonry walls to keep interiors cool by day and warm by night, and inner courtyards for privacy, were adapted from the hot climates of the Iberian peninsula, southern Italy, and North Africa. Pastiches of romantic effects that evoked, rather than reproduced, the Mediterranean style called for colorful glazed tiles and mosaics, sculpted heraldry, Moorish-style towers, baroque finials, and the use of barrel tile.

With its beautiful stone fountains, pergolas, pathways, colonnades, bridges, and sculptural entrances, Coral Gables, built entirely during the 1920s, is a rare example of a city planned like a garden. Stonework etched with moss, walls crowned by cascading bougainvillea, boulevards lined with live oak allées, and streets canopied by massive banyan limbs give the city its botanically magical identity.

Few contemporary cities possess such romantic allure because few towns built during this century were conceived by developers who were as enamored of Mediterranean charm as Coral Gables' visionary, George Merrick. The son of a Congregationalist minister, Merrick was a poet at heart and a capable businessman in practice. As a boy, his long trips by horsecart between the Merrick family grapefruit plantation and what was, early in the 1900s, downtown Miami, gave him hours every day to read and write poetry and to dream. By 1921, having taken over his father's citrus business and succeeded in a number of local real

AT LEFT:
Detail of a Coral Gables fountain and entrance.

Detail from a Mediterranean-style loggia.

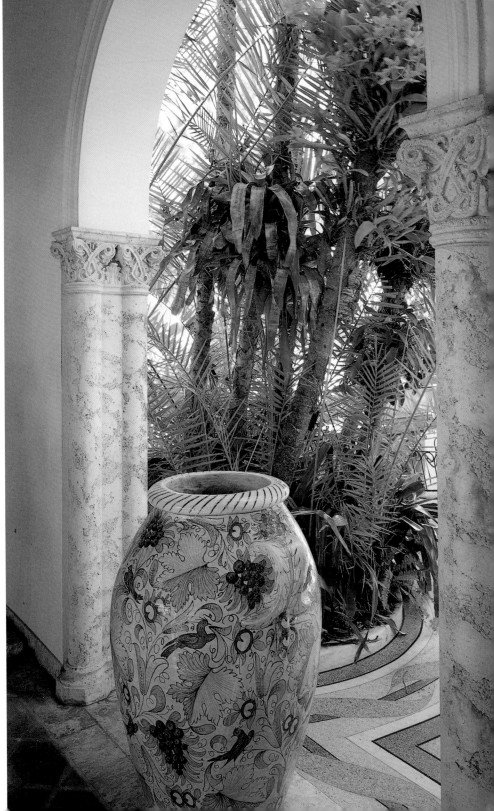

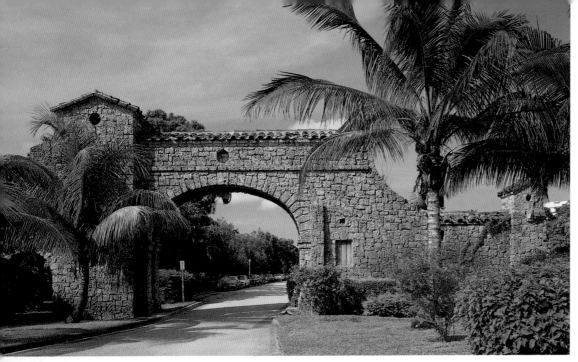

The Commercial Entrance, Madeira Avenue and Douglas Road.

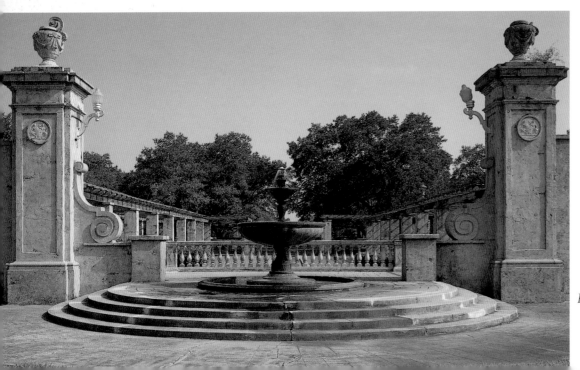

A Granada entrance at Coral Way.

Fountain and colonnade of the Country Club Prado entrance.

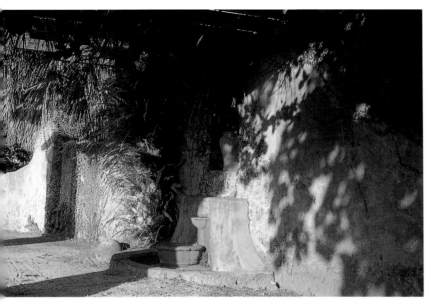

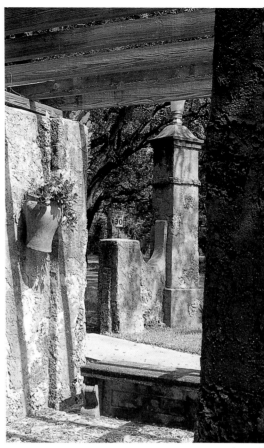

Details of Coral Gables entrances.

estate ventures, he decided to shape his dreams into the form of a city. Absorbed by pictures he found in books such as Baedecker's *Guide to Spain* and Washington Irving's *The Alhambra*, as well as by his own travels in Mexico and Central America, he became convinced of the stylistic possibilities of adapting Spanish and Moorish architecture to this locale. "The gleaming white coral rock, the palm trees, tropical flowers and verdure seem to me to provide a natural setting with which Spanish design would harmonize," he wrote.

Merrick understood that to make his development stand apart from the rest of pioneer Miami, both literally and aesthetically, he needed to provide some sort of stylistic announcement, a monumental definition of the specialness that lay within his boundaries. To accomplish the mission, he called upon his uncle, artist Denman Fink; landscape architect Frank Button; and architects Walter de Garmo and Phineas Paist to design a series of architectural entrances that evoked the tradition of Spanish sen-

tinels. They were crafted from locally quarried coral rock which was crushed, mixed with cement, and then shaped by artisans—among them stone mason Charles Merrick, George's brother. The barrel tiles used to roof them were salvaged from Cuban ruins where they had originally been formed by hand over the thighs of Spanish workmen and used as ballast in trading ships coming to the New World.

As intrinsic as the entrances were in establishing a mood and identity for Coral Gables, its fountains were important in sustaining an aura throughout the city. Merrick relied once again on the tastes and imagination of Denman Fink, who was a renowned colorist and a recognized authority on Spanish art

and architecture. Frank Button conceived the fountains' landscape plans, which incorporated a wealth of bougainvillea and other tropical vines.

In addition, Merrick transformed an abandoned quarry into a spectacular swimming hole, the Venetian pool, and carved out a system of winding Venetian-style waterways, which he stocked with twenty-five gondolas and gondoliers. This timeless combination of water and botanical features indelibly inscribed Coral Gables in the imaginations of all who visited—and settled—here.

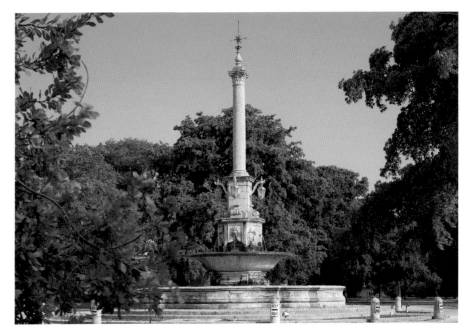

The De Soto Fountain at Granada Boulevard and Sevilla Avenue.

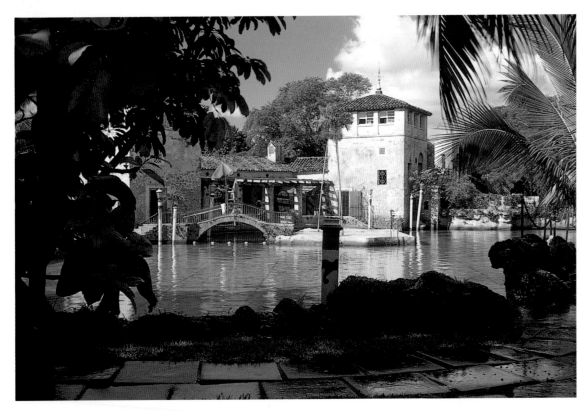

Venetian Pool, created out of a coral rock quarry.

PARROT JUNGLE

Miami

The sign that greeted visitors for more than fifty years.

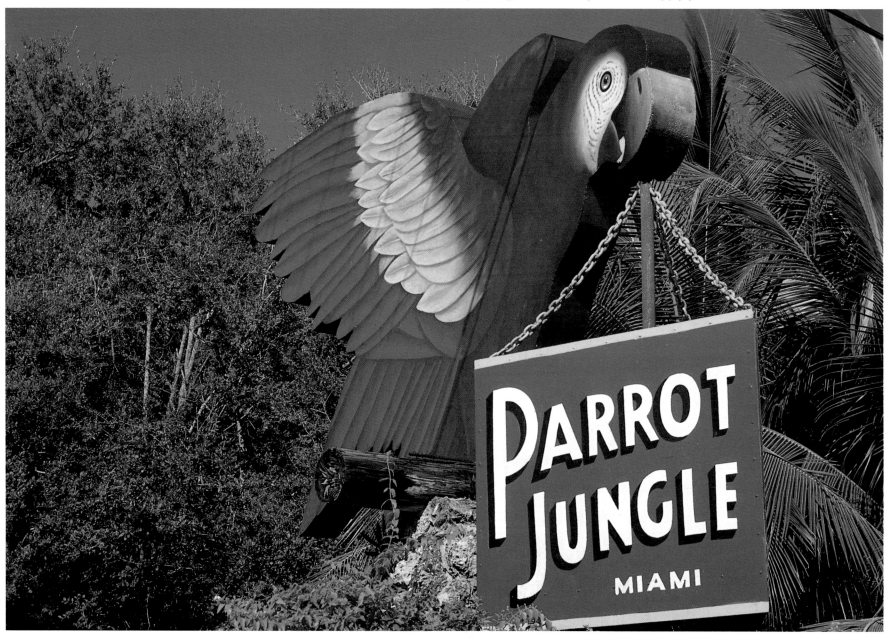

Canna lilies, yellow and green crotons, and a climbing aroid.

BELOW:
Examples of the more than two hundred varieties of cactus and succulents growing in the Desert Garden.

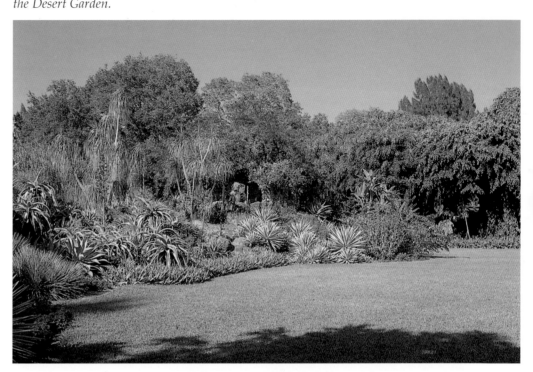

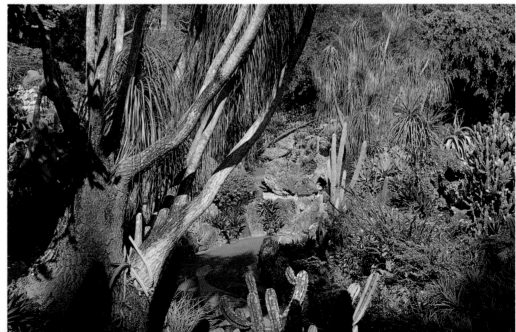

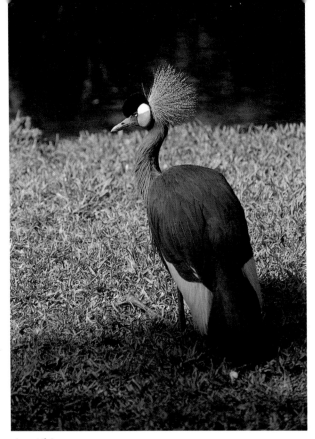

An African crown crane.

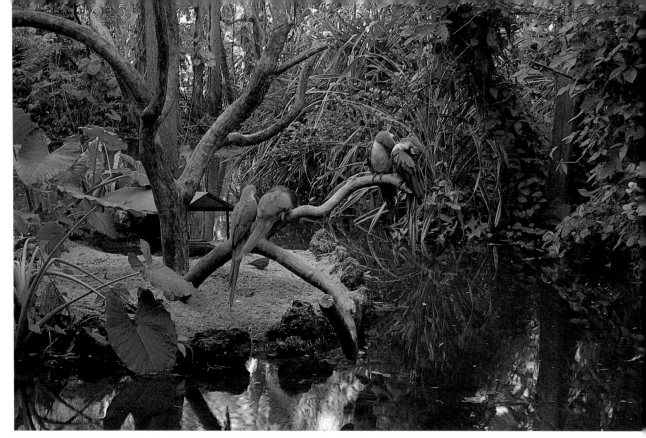

A hidden island in dense jungle growth.

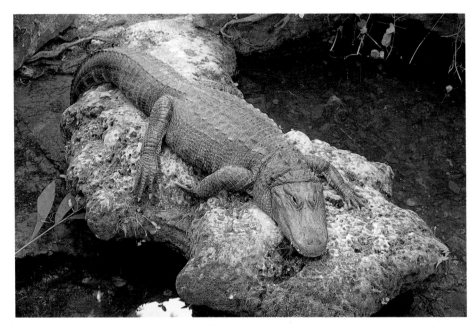

A Florida alligator.

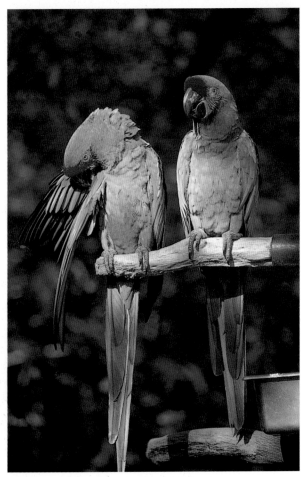

Two of the garden's parrots that fly freely.

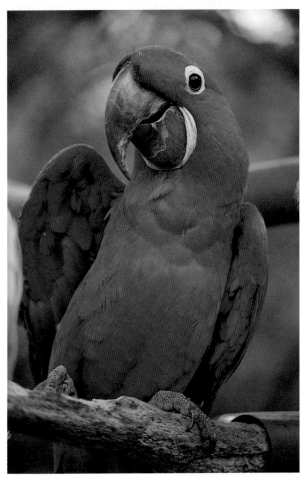

Ray, an Amazon macaw.

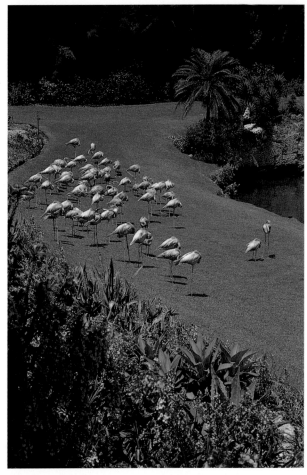

The famous pink flamingoes in the three-acre Flamingo Lake.

With its feathers, flowers, colors, vistas, 40-foot-high palms, and 15-foot-long alligators, Parrot Jungle could easily have been conceived by the Hollywood extravaganza director of the 1930s, Busby Berkeley. So dreamy and colorful is the twelve-acre setting that even the twenty-five pairs of macaws that are released every morning to fly freely around Miami return eagerly each night when called by name.

More than 1,100 birds (75 species of parrots, cranes, macaws, geese, peafowl, native ibis, swans, exotic ducks, spoonbills, cockatiels, cockatoos, parakeets, lovebirds, crowned pigeons, peacocks, and the famous flock of over 80 flamingoes) live here among 100 different varieties of cactus and succulents and 2,000 varieties of tropical and subtropical plants and trees.

Originally a twenty-acre cypress and oak hammock, the garden was started in the late 1930s by Austrian-born Franz Scherr. With $5,000 from the mortgage of his home, he purchased the land, hired a crew to help him clear trails, erected a pine entryway with a thatched roof, and opened the attraction with six

A floral background frames a giant aloe vera.

macaws, an alligator, a rattlesnake, a deodorized skunk, and a bunch of raccoons. The first year, 10,000 tourists paid twenty-five cents each to walk through the swampy setting. Today, approximately 300,000 people a year wander the wonderland, observe bird-training sessions, attend the trained-parrot shows in the amphitheater, and pose for their classic snapshots with the birds.

The garden, though informally planned, offers a large variety of horticultural attractions. Its plantings range from water-loving plants such as heliconia and other gingers to high-ground plants such as hibiscus and crotons; from plants that require full sun, such as bougainvillea and flame vine, to those that thrive in complete shade. The Desert Garden, planted in the 1950s, con-

tains more than 200 varieties of cactus and succulents. A three-acre lake provides an fantastically glamorous backdrop for the flamingoes.

The Scherr family sold Parrot Jungle in the late 1980s. Its present owners plan eventually to move the attraction—birds, alligators, and all—to Watson Island, off the causeway between Miami and Miami Beach. After fifty years of training macaws, Parrot Jungle's bird trainers are confident the colorful creatures, so familiar in Miami's skies, will have no problem finding their new way home.

BELOW:
The famous pink flamingoes in the three-acre Flamingo Lake.

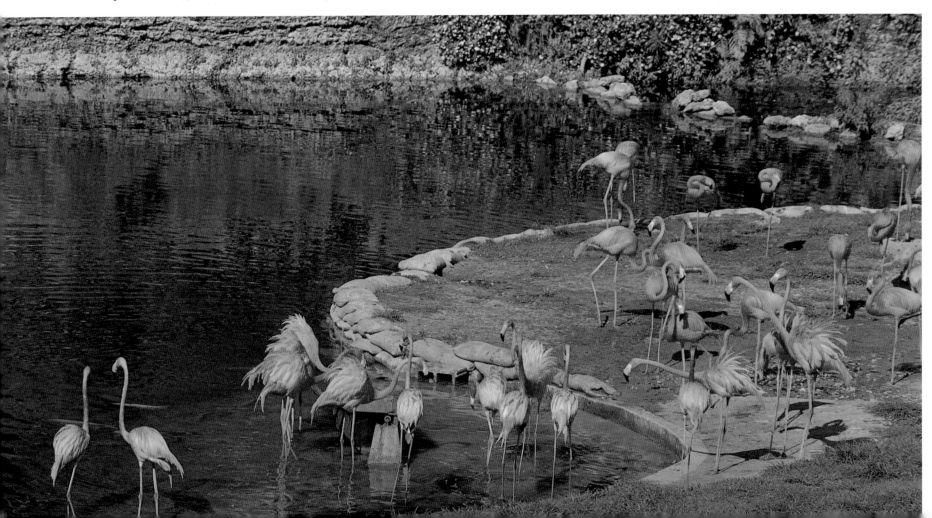

FAIRCHILD TROPICAL GARDEN

Miami

Located along Miami's historic, winding Old Cutler Road, the Fairchild Tropical Garden is the largest tropical botanical garden in the continental United States. It was named after David Fairchild, the first chief of plant exploration for the U.S. Department of Agriculture, who brought back from around the world thousands of edible and ornamental plants that not only influenced agriculture, but also changed the American diet. The garden contains more than six thousand plants, among them some of the world's finest collections—in both quantity and

A view of the garden's library, bookstore, and office building.

AT RIGHT:
The small pool in the Bailey Palm Glade, home to an occasional alligator.

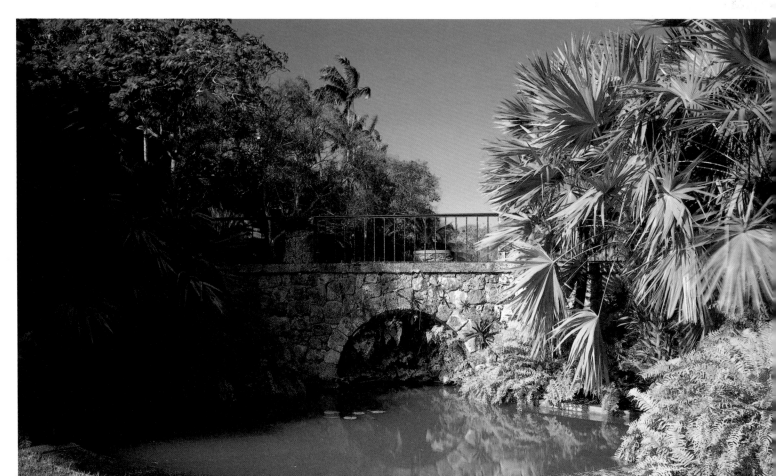

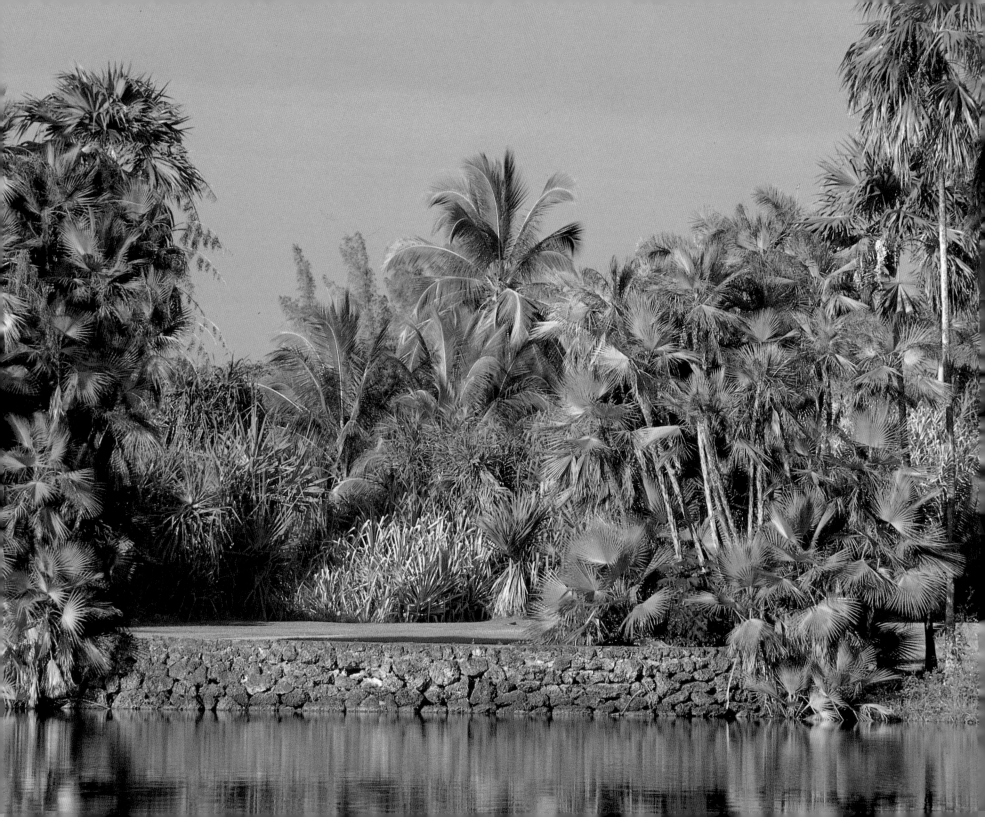

Palm leaves and philodendron.

Detail of the beautiful handcarved keystone wall.

AT LEFT:
An overview of the garden.

AT RIGHT:
Detail of palm leaves.

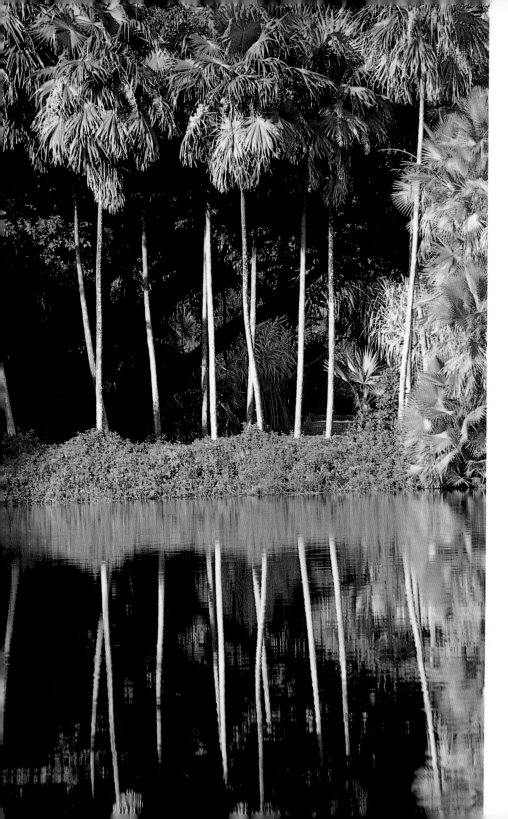

quality—of palms, flowering plants, aroids, ferns, Bahamian plants, bromeliads, and orchids.

The Garden was founded in 1938 by Colonel Robert H. Montgomery, a tax accountant, self-made millionaire, and avid gardener whose passion was cultivating his personal collection of palms and cycads. In time, his plant collection outgrew his private estate, and the colonel began looking for a way to make it accessible to the public. Learning that David Fairchild had retired to Miami, Montgomery approached the famed horticulturist. Together they began working on plans for Montgomery's eighty-three-acre gift to Miami.

To design the site, Montgomery hired William Lyman Phillips, a landscape architect who had begun his career in the Boston offices of the famed Frederick Law Olmstead. Phillips was the designer of New York's Central Park, Prospect Park, and Forest Hills, as well as scores of other outstanding landscapes throughout the

AT LEFT:
Palms in reflection.

BELOW:
Poinciana in bloom.

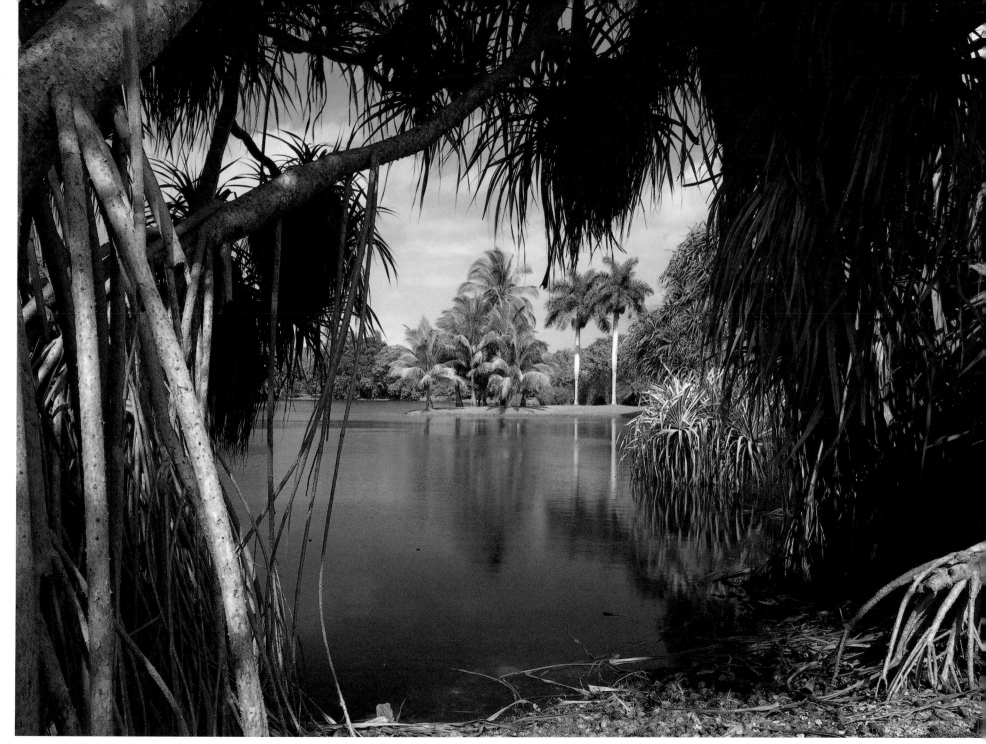

Pandanus Lake.

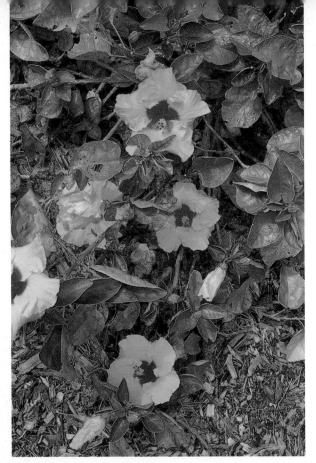

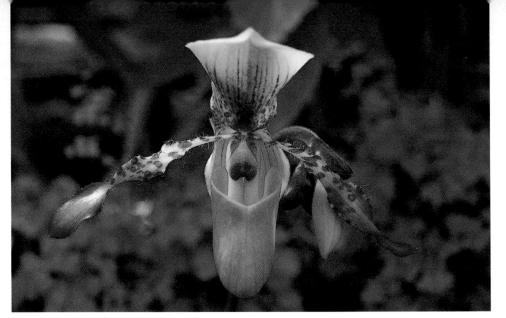

A paphiopedalum orchid.

Vivid hibiscus.

BELOW:
Hibiscus cultivars.

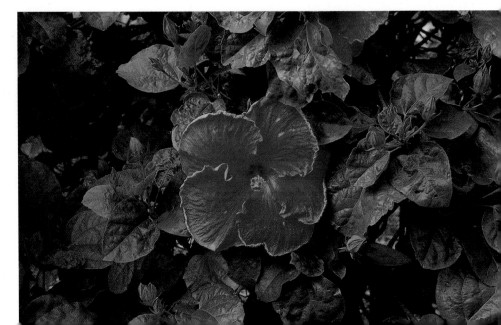

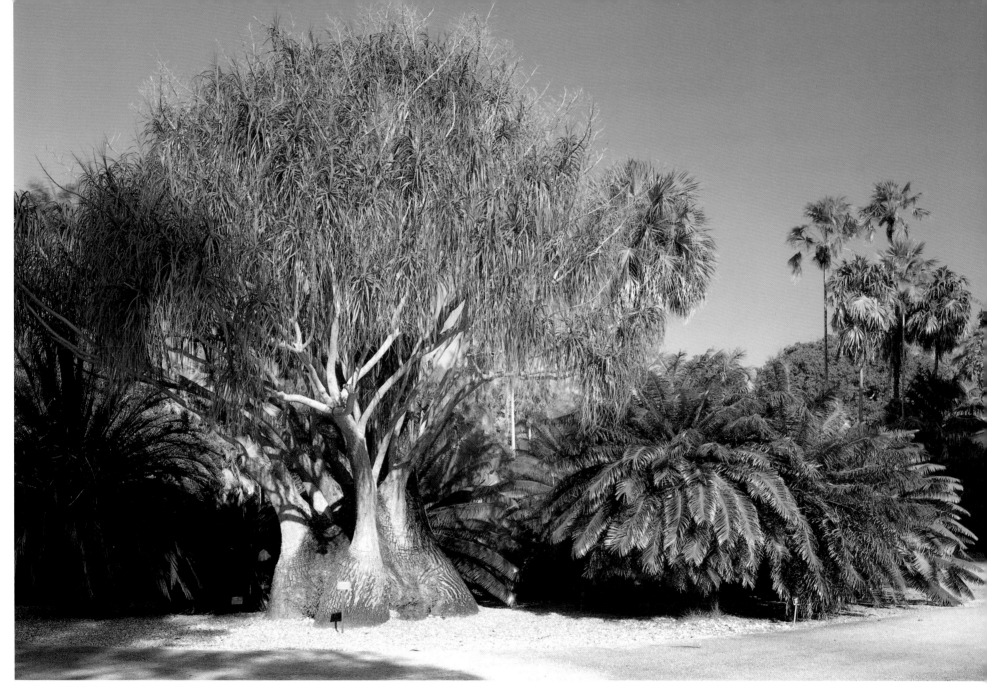

Baobob tree and cycad.

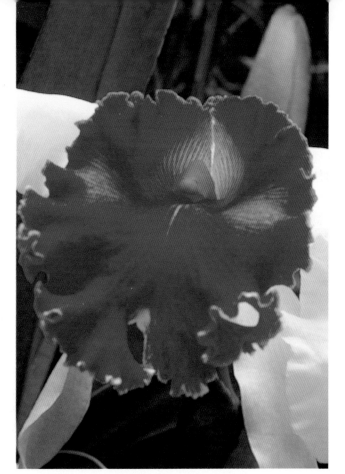
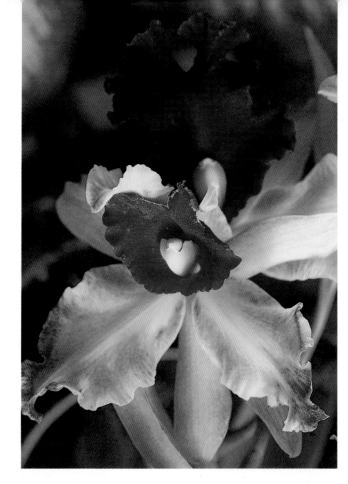

Cattleya hybrid orchids.

U.S. Phillips, who had visited botanical gardens throughout Europe, had come to Florida originally to design the gardens of Pinewood House, the Lake Wales estate of Charles Austin Buck, vice-president of Bethlehem Steel near Bok Tower. At the time he met Montgomery, he was working on Matheson Hammock Park, adjacent to the Fairchild site.

In full appreciation of Montgomery and Fairchild's desires, Phillips designed a garden filled with lush variety. It features eleven lakes, two dramatic vistas, a twenty-five-acre palmetum, and paths that wind through a tropical rain forest, a fern glade, a rock and cactus garden, and a hibiscus garden. He also included a flowering vine pergola, a cycad circle, a sunken garden, and a rare plant house.

Phillips contrasted compact, informally grouped masses of plants with wide lawns and expansive vistas, producing an effect of ever-changing scale and anticipation. For plants indigenous to southern Florida, the Florida Keys, and the Bahamas, he created areas that simulate their native environments. Endangered Florida species such as the buccaneer palm from the Florida Keys and the royal palm also grow, preserved, here.

Orchids, bromeliads, giant tree ferns, and other exotic plants are on perpetual display in the garden's rare plant house. And flowering plants of one kind or another, such as hibiscus, red silk-cotton trees, and bougainvillea vines, are in bloom throughout the year.

VIZCAYA

Miami

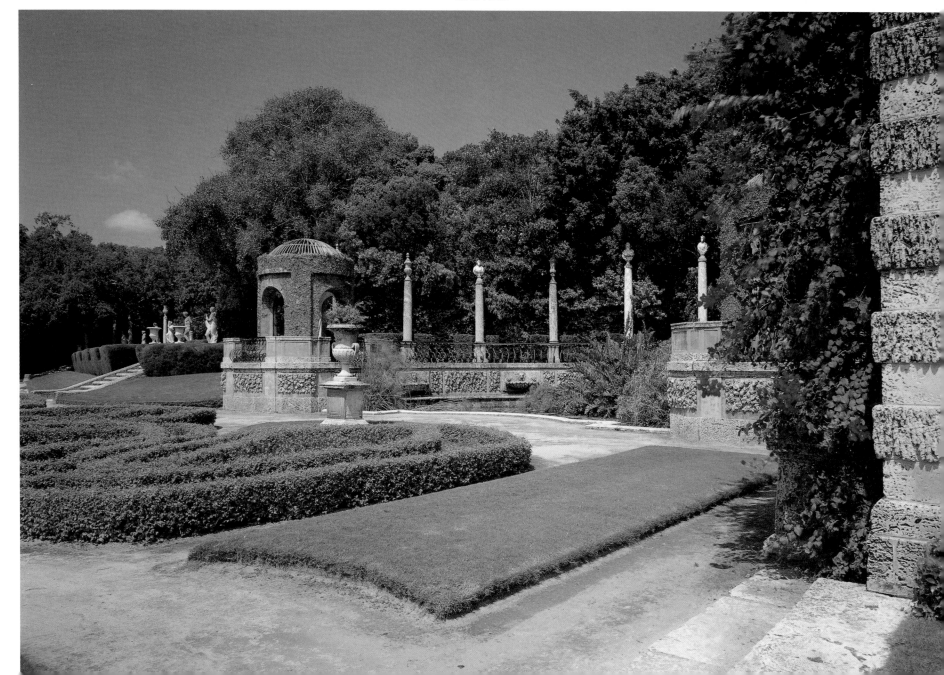

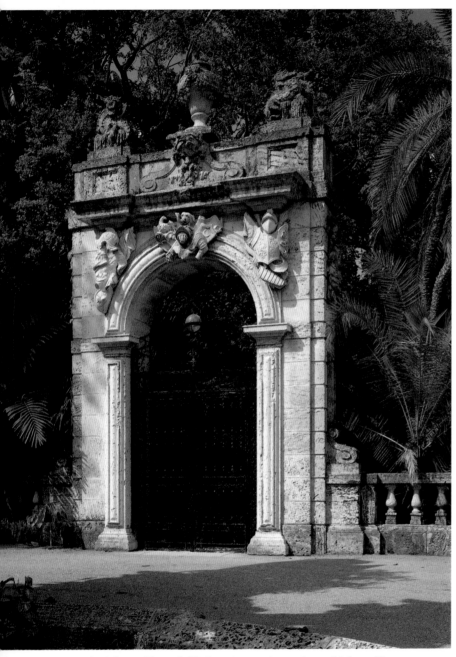

A pink marble and Sitrian stone gateway brought from Verona, surmounted by carved limestone seahorses, one of Deering's symbols for Vizcaya.

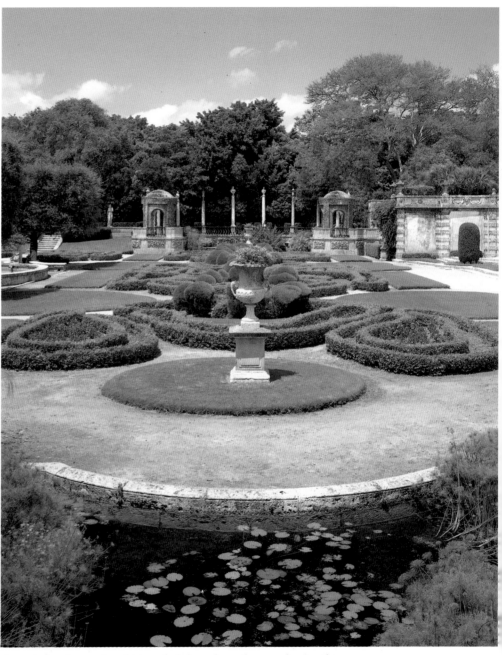

A semi-circular pool and vine-clad domed gazebos emphasize the formality of the garden design.

Industrialist James Deering, cultured, well traveled, and cofounder and vice-president of International Harvester, could have built his winter home in Egypt, North Africa, the Riviera, Spain, South America, the South Seas, or the Orient—any warm exotic climate, anywhere in the world. He chose, instead, 180 acres of isolated mangrove and hardwood hammock in a scarcely pioneered region of America. In 1914 James Deering broke ground in newly settled Miami, where his family owned property, for a thirty-room Italian Renaissance-style villa that would become one of this country's great houses. He called it Vizcaya, meaning "elevated place" in Basque.

Unlike most of the sprawling mansions built in America between the Civil War and the Great Depression—the extravagant "cottages" of Newport, the voluptuous salons of Fifth Avenue, and the monuments to grandeur and excess such as San Simeon—Vizcaya came to stand apart as a rare example of good taste, appreciation of history, and sensitivity to nature.

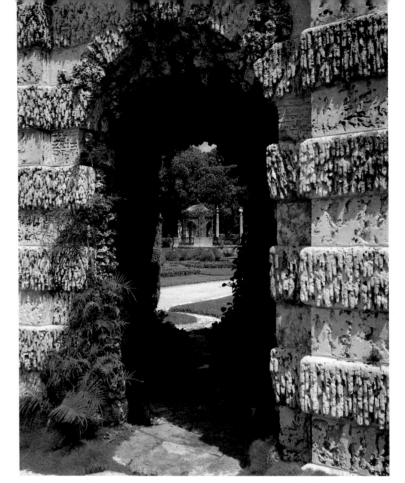

A domed gazebo seen through the grotto entrance to the Secret Garden.

The reasons for its excellence lie in Deering's own sensibilities as well as the talents of the men he chose to design his residential masterpiece. First was Paul Chalfin, a painter, designer, and curator, who was introduced to Deering by the famous interior designer Elsie De Wolfe. Deering and Chalfin traveled throughout Europe gathering ideas, art, and furniture for Vizcaya. Chalfin at first considered Spanish architecture to be the most fitting for the project, but after visiting Italy, he came to prefer the

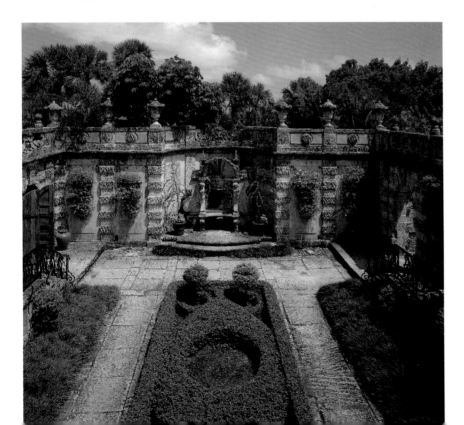

AT LEFT:
The walled Secret Garden.

39

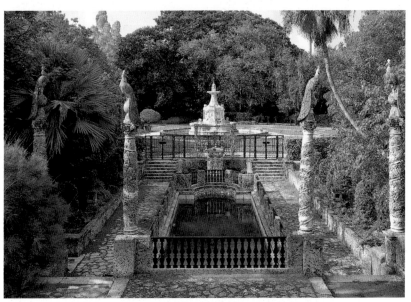

Columns surmounted by carved peacocks overlook the Fountain Garden.

A sarcophagus-shaped fountain by Charles Cary Rumsey.

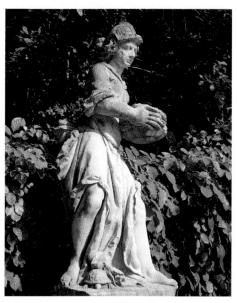

Minerva, Roman goddess of wisdom and the arts.

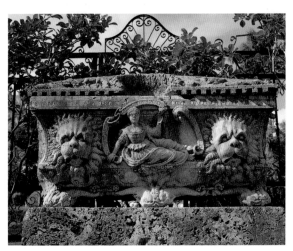

A sixteenth-century carved stone sarcophagus.

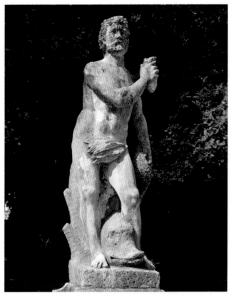

Neptune, God of the sea.

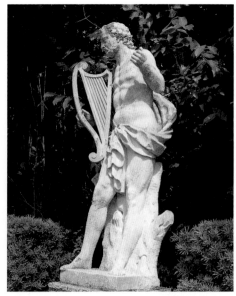

Apollo, Greek god of poetry and music.

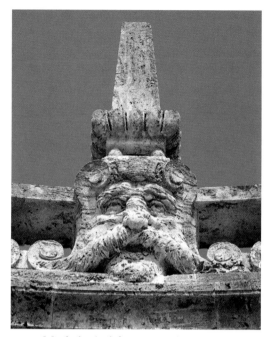
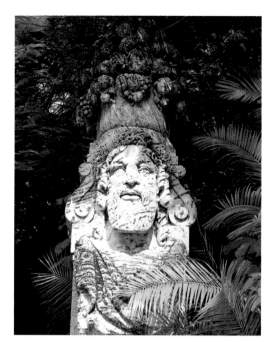

Mythological faces carved in native limestone.

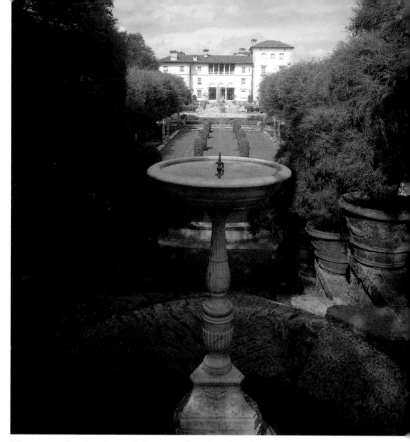

The central axis view of the west facade of Villa Vizcaya from the Mount with sixteenth-century marble font in foreground.

Italian style of the sixteenth and seventeenth centuries. To handle the actual architectural design, Deering brought in F. Burrall Hoffman, Jr., a Harvard graduate who, like Chalfin, had also studied at the Ecole des Beaux Arts in Paris. The third member of the team was Diego Suarez, a Colombian-born, Italian-trained landscape architect whom Deering and Chalfin had met during one of their trips abroad. Suarez had shown them villas and gardens in Florence, and their interest led to his commission to design the gardens at Vizcaya.

Suarez's efforts centered on the ten-acre formal garden, which incorporated a French parterre—an arrangement of low, clipped, curvilinear hedges; a fountain garden designed like an ancient Persian garden; a theater garden for music and entertainment; a secret garden with walls of locally quarried limestone; a maze; a lagoon; tropical outer gardens connected by bridges; a large boathouse with a roof garden; and winding drives through groves of palm and other trees.

To synthesize all these diverse and luxurious elements, Suarez devised a fan-shaped plan that continued the north-south axis of the house, symmetrically balancing its architectural features and incorporating expansive vistas within the complexity of intermingling parterres and long-reaching allées. The effect is symphonic, a harmony of Italian Renaissance design, baroque curves, and French intricacy. Especially surprising is the clarity of the design, considering the disorder that could so easily come with the mixture of so many styles. Suarez's brilliance lay not only in the scope and detailing of his garden plan, but also in his adaptation of his Italian design with tropical vegetation conducive to South Florida's climate. For example, instead of traditional

41

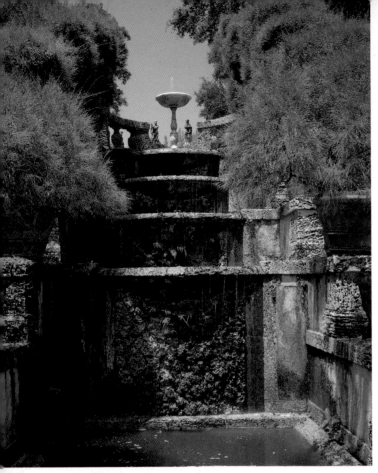

The water stairway, reminiscent of that at the Villa Corsini in Rome.

columns, sixteen of indigenous limestone, fourteen imported from Europe, and two excavated from ancient Roman ruins.

It took nearly eight years to complete Vizcaya's grounds and required eighty people to maintain the finished garden and working farm to James Deering's standards. New flowers opened daily, to Deering's delight (cut flowers for the house were grown in the greenhouses, *never* cut from the formal gardens), and waterlilies floated in the reflecting pool for him and his guests to gaze upon.

But Deering was to savor the pleasures of his private Eden for only two years. He died while returning from Europe on the SS *Paris* in 1925. Then, in 1926, a hurricane ravaged his beloved grounds. Nothing of Vizcaya's original scale was ever attempted here again.

In 1952, Dade County acquired thirty acres of the estate and

boxwood hedges, he planted fragrant jasmine. For his high hedges, he used the locally prevalent Australian pine.

Besides their natural beauty and superb design, the gardens came to be further distinguished with hundreds of decorative ornaments procured or commissioned by Paul Chalfin. In the tradition of Versailles, he used life-size statues of mythological figures—Jupiter, Mars, Venus, Adonis—to grace the walk and gardens. For height and verticality in the landscape, he used

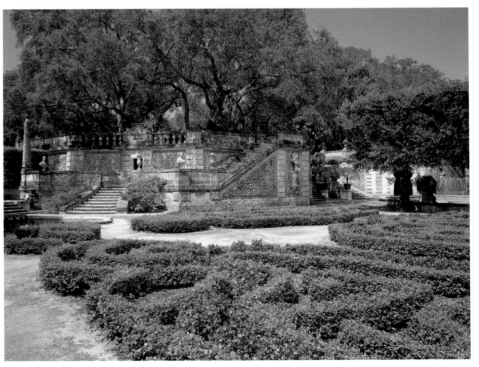

A profusion of carved stone ornaments and floral plantings characterizes the formal garden.

42

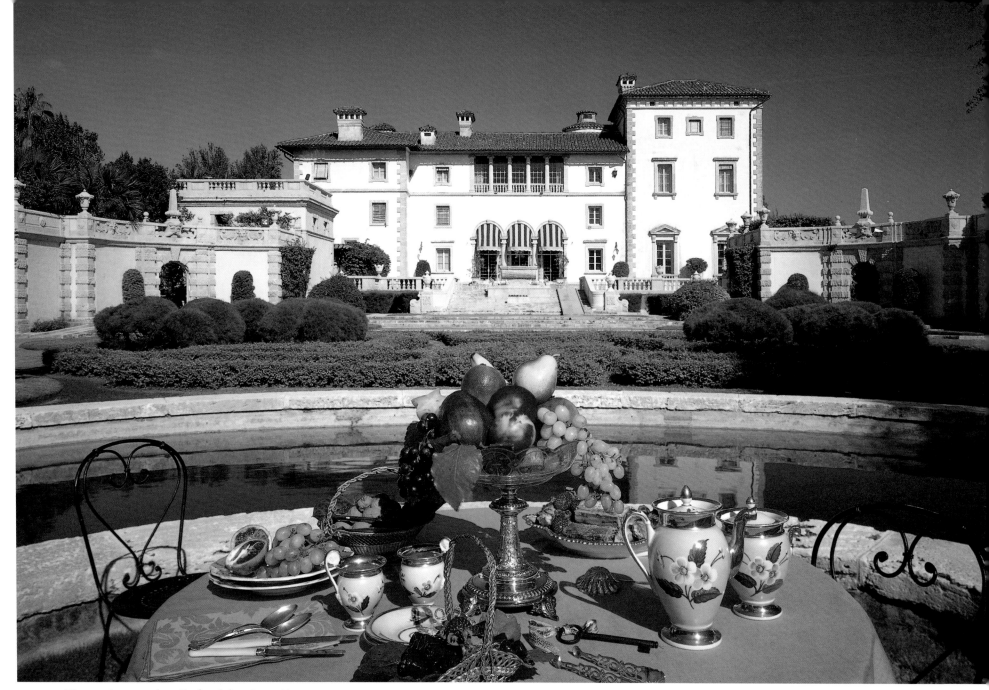

Vizcaya is a popular site for elaborate parties.

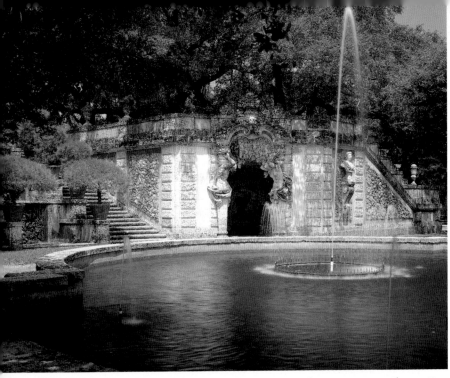

A view of the water stairway leading to the Mount and an entrance to the grotto.

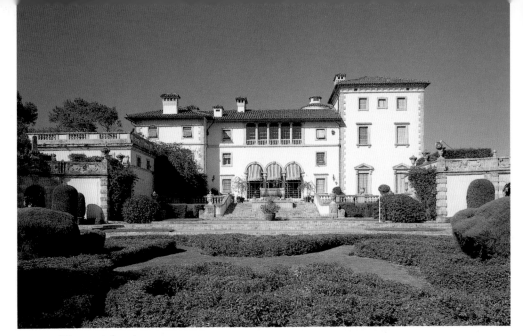

The west facade.

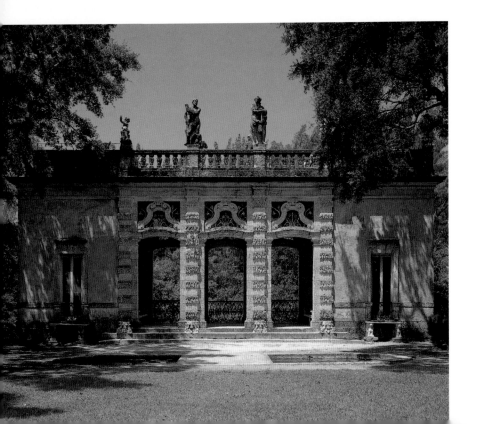

turned Vizcaya into a museum and public garden. For more than twenty-five years, Roger Fosse, a Frenchman who trained at Versailles, supervised the villa's landscape, overseeing its restoration and constantly maintaining its high level of care with only five gardeners.

Because it is now a public garden, the thorny bougainvillea have been replaced with safer jasmine, and each November 2,000 begonias are planted to add the color Deering so loved.

Eighty years after its inception, Vizcaya continues to give pleasure. In a climate that favors the wild, the sultry, and the excessive, it remains enclosed, formal, and restrained. In an age when civility all too often gives way to the quick and easy, it endures as a monument to beauty.

The Casino with loggia and eighteenth century-style interior, designed as a setting for tea.

FLAMINGO GARDENS

Ft. Lauderdale

While developing a thriving South Florida citrus business during the late 1920s, Floyd and Jane Wray built themselves a retreat on sixty acres of Everglades oak hammock. Surrounding their weekend house, which is sited on Pine Island Ridge, they planted citrus trees and an arboretum of tropical and subtropical trees. This was the beginning of Flamingo Gardens, the living museum which Jane Wray formally established in 1959 as a memorial to her husband. Today it is home to numerous plant, tree, and wildlife gardens; a wetland; a xeriscape; and the largest collection of champion trees (twenty-two) in the state of Florida.

Soon after the garden's inauguration, the Plant Introduction Board, which today is a part of the Department of Agriculture, chose the site for the planting and study of tropical trees. Specimens were brought from around the world, including such distant countries as India, China, Polynesia, and the Philippines. The gardens' fertile hammock soil made the location an excellent choice. The most dramatic evidence is the number of champion trees on view. A champion tree is the largest tree of a species, determined by calculations of height, girth, and spread, and designated by the American Forestry Association.

Among the most spectacular of the champions growing at Flamingo Gardens is the largest tree in Florida, a Cluster Fig, *Ficus racemosa*, which stands 108 feet tall. The Panama Candle Tree, *Parmentiera cereifera*, which is among the arboretum's most spectacular specimens, bears not only pendulous, waxy, yellow fruits resembling candles, but also magnificent bouquets of bell-shaped white flowers.

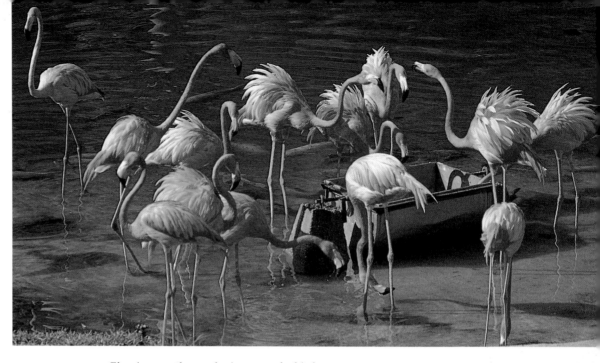

Flamingoes, the garden's namesake birds.

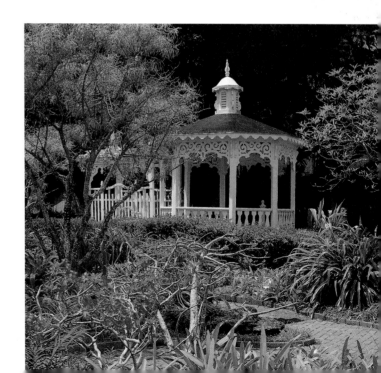

The gazebo with gingerbread fretwork and cupola.

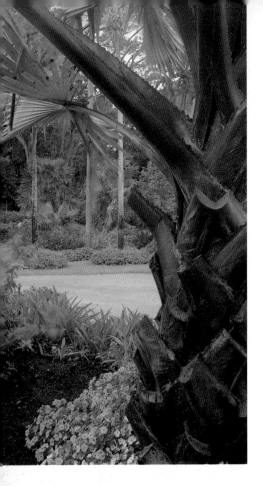

Impatiens are used densely throughout the garden.

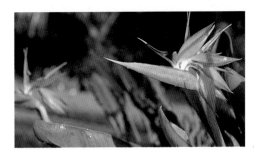

Birds of paradise.

Today trams and walkways carry visitors to the Arboretum, the Wetlands (a re-established native ecosystem), the Butterfly Garden, the Hummingbird Garden, the Xeriscape Garden, and flowering gardens as well as, among other features, an Aviary, a Tropical Plant House, and the restored Wray House, which is listed on the State Historic Registry.

The garden offers a view of thousands of tropical plants and palms. Orchids, ferns, bromeliads, and other exotic specimens live in the trees. Gingers, bananas, and birds of paradise adorn paths and trails. The Xeriscape Garden displays a large inventory of plants that require no direct artificial irrigation. The artificially created 1.6-acre Wetlands attract herons, osprey, ibis, and woodstorks.

The Bird of Prey exhibit has Florida's largest collection of native wading birds. In the Aviary live examples of southern Florida's five major ecosystems. The Everglades Wildlife Sanctuary provides a home to the Garden's namesake, the flamingo (as well as river otters and alligators). Altogether, the Wetlands, the Aviary, and the Wildlife Sanctuary hold a collection of more than ninety species of birds.

Working citrus groves provide an homage to the tree responsible for inception of the garden. Visitors can see how the citrus industry works—how the fruit is harvested, washed, waxed, sorted, put into bins, and sold. Fresh juice is prepared daily.

A profusion of golden shrimp plants.

BONNET HOUSE

Ft. Lauderdale

When Chicago art collector and renowned muralist Frederic Clay Bartlett married Helen Birch, the daughter of Florida pioneer and philanthropist Hugh Taylor Birch, in 1918, Birch made the couple a wedding gift of thirty-six acres of what is now downtown Ft. Lauderdale. Unlike other wealthy newcomers to Florida who sought to use their real estate to build glamorous playgrounds for America's restless rich, Frederic Bartlett was interested only in creating a winter family retreat that would serve as a stimulating setting for his greatest passion—art.

Although Bartlett had studied painting at the Royal Academy in Munich and with James McNeil Whistler in Paris, it was this wilderness location that proved his greatest inspiration, even though the site was devoid of topsoil and covered with nothing but sand. Bartlett dug four feet down, spread manure and black earth, and began cultivating a landscape of exotic subtropicality, complete with a jungly path to the nearby ocean and private

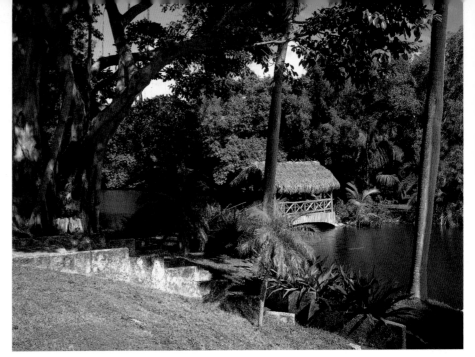

The thatched-roof covered bridge.

beach front. Sea grape, ficus, mahogany, and banyan trees already grew in abundance on the estate. With Bartlett's help, soon gardenias perfumed the air and shrimp plants and crotons enlivened it with color.

Dominating the landscape was a succession of three freshwater ponds for which the couple imported black and white Australian swans. The Bartletts hired local Seminole Indians to construct an open-sided, thatched-roof "chickee," a type of building characteristic of the Seminoles, in the form of a bridge that would divide the two larger ponds. From their chickee, the Bartletts could look out on the yellow Bonnet waterlilies that grew prolifically in the ponds. In fact, the couple was so enamored of the flower that they named their retreat after it.

The estate is made up of a large and comfortable Caribbean plantation-style main house with an uncultivated-looking landscape. Frederic Bartlett designed the features on the eastern portion of the property in an unobtrusive way that took advantage of the extraordinary natural setting. The entry drive, for example, is a

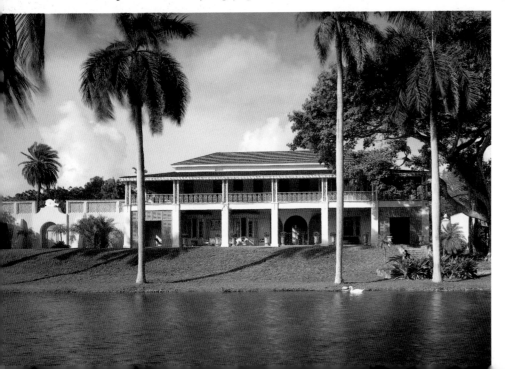

AT LEFT:
View of the Bartlett house as seen across the lake.

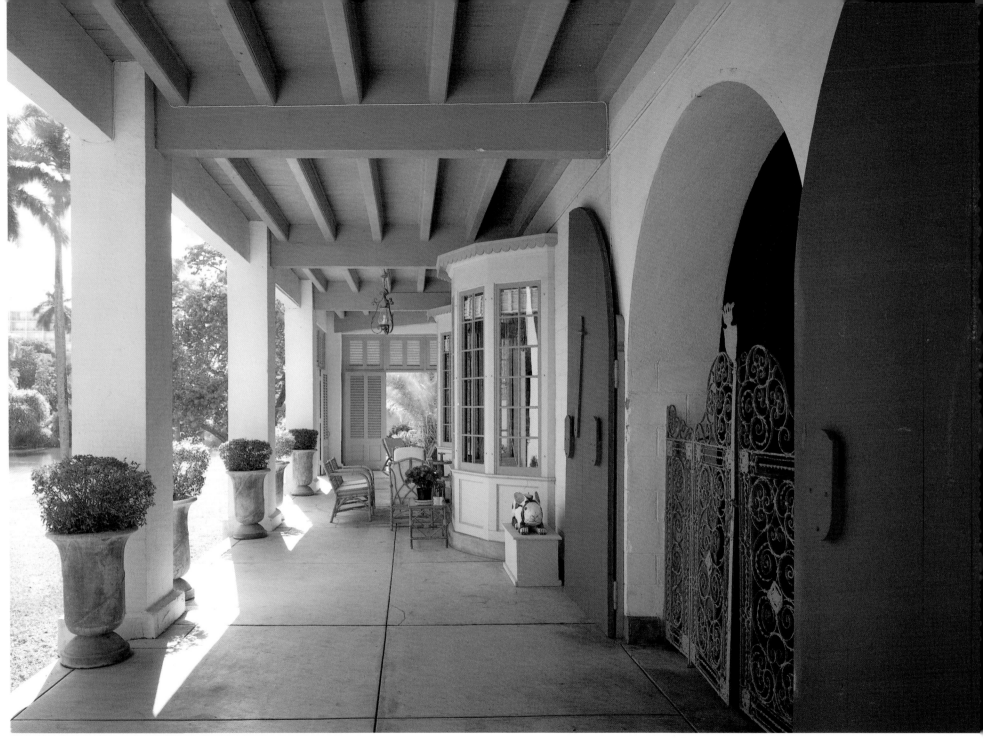

The loggia overlooking the water.

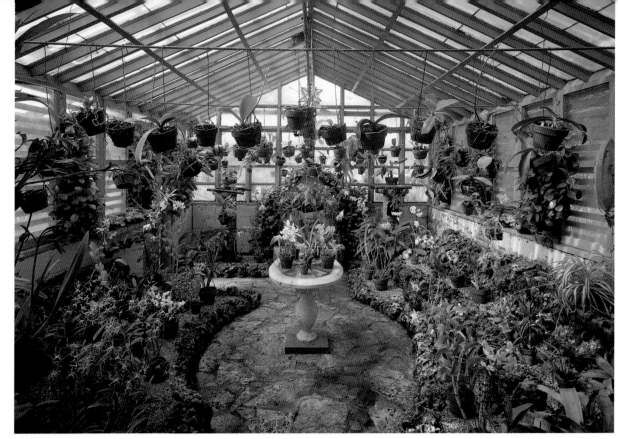

The keystone walkway.　　　　　　　　　　*Interior of Mrs. Bartlett's orchid house.*

tree-lined allée that runs along the banks of a canal flowing off the nearby Intracoastal Waterway. Outbuildings are not only simple in style, but also were sited so that leisure activities could take place in contact with nature. An informal theater, for example, was built on a circular plot north of the two main ponds. It is surrounded by a coconut-palm-lined moat; outside the moat, stands of native trees emphasize the luxuriance of the setting. South of the main ponds, a circular lily pond can be viewed from a simple pavilion.

Helen Birch Bartlett did not live to see all that her husband accomplished; she died in 1925, scarcely four years after the building of Bonnet House had begun. Six years later Frederic remarried, taking as his new wife Evelyn Fortune Lily of the Eli Lily pharma-

ceutical family. A woman of enormous creative drive, she put a mark on Bonnet House as pronounced as that of her husband.

Well over 100 years old, Mrs. Bartlett is still in residence from December through May, cultivating her orchid collection (one of the largest in the U.S.), which has over 1,500 plants. She has seen to it over the decades that the landscape of Bonnet House has remained natural. In 1983, she deeded the house and its grounds, valued then at nearly $40 million, to the Florida Trust for Historic Preservation, and a restoration program was begun. Today, because of Frederick Bartlett's design efforts, Evelyn Bartlett's work in caring for the estate, and the community's interest in its preservation and development, the best of the past remains for all to see.

50

MORIKAMI JAPANESE GARDEN

Boca Raton

The Morikami Japanese Garden, named after George Sukeji Morikami, who donated the property to Palm Beach County in 1974, is a subtropical interpretation of the traditional Japanese garden—a setting specifically designed to inspire tranquillity and contemplation. Whereas most Florida gardens showcase the

BELOW:
Kanabiki-no-taki, the park's waterfall.

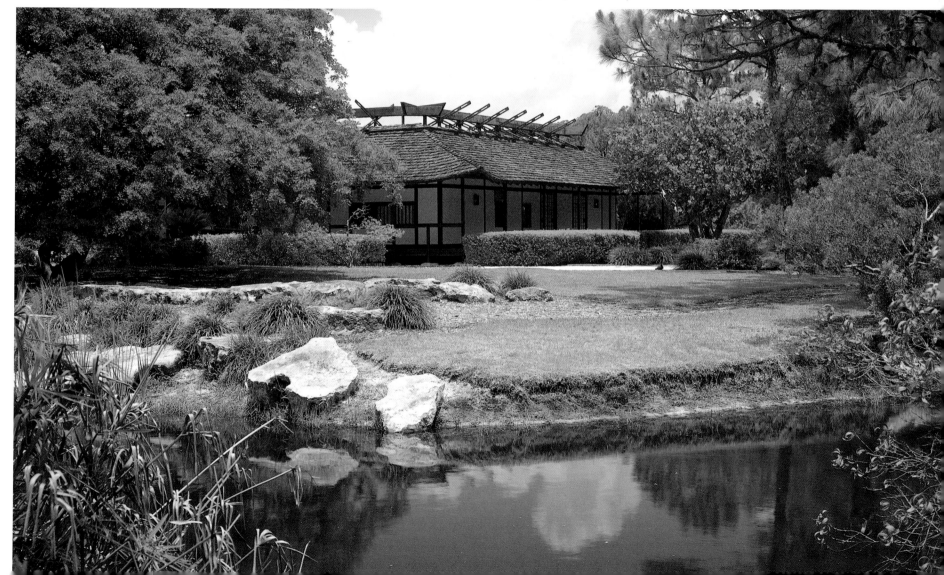

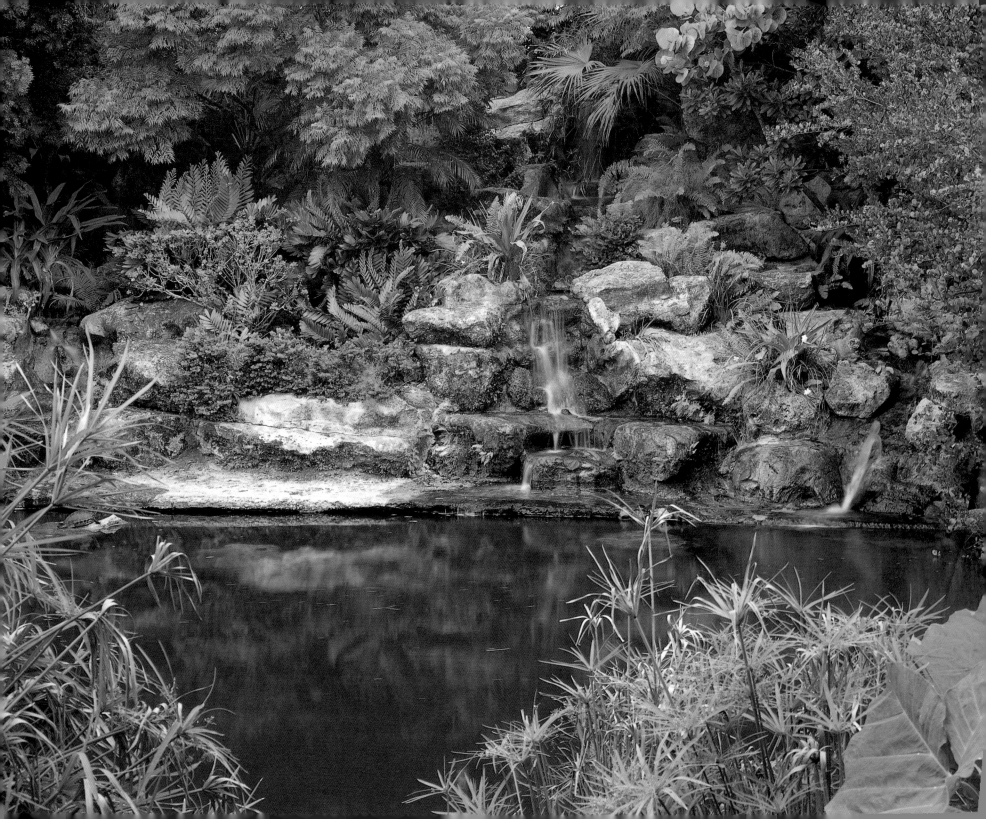

AT LEFT:
The Morikami Museum.

A view through Koro-en, the sparkling dew garden.

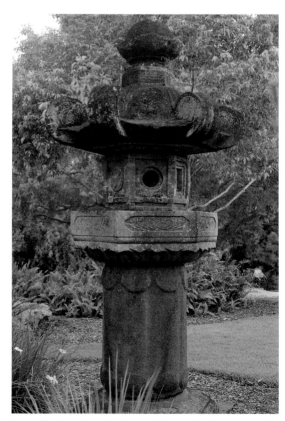

Detail of the Lee Peckman Memorial Garden with carved granite stone lantern.

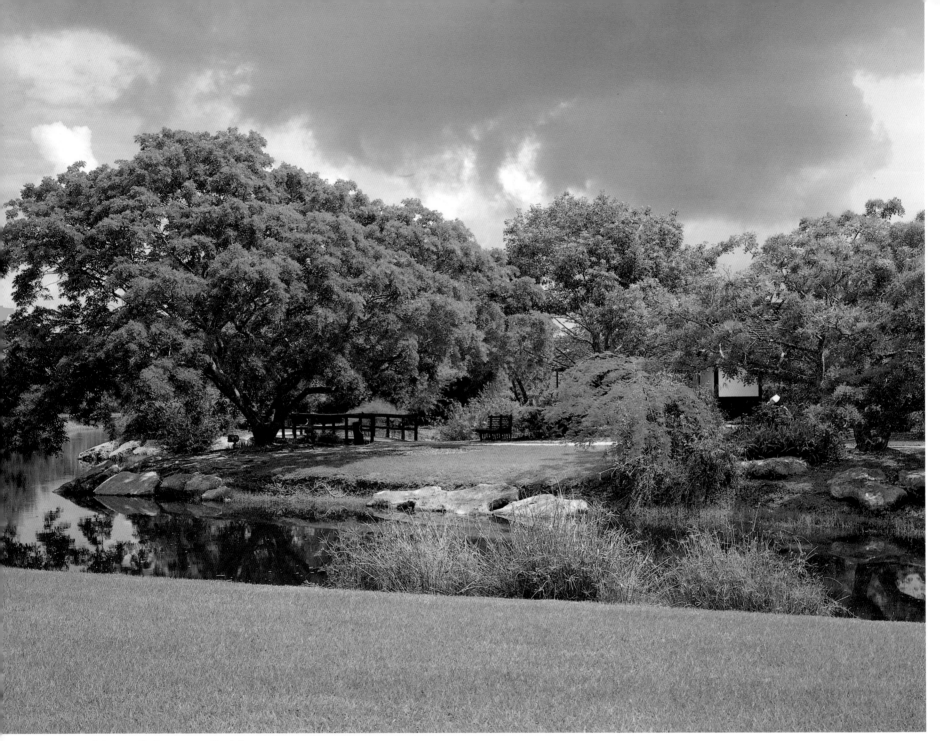

A tranquil view across the lake.

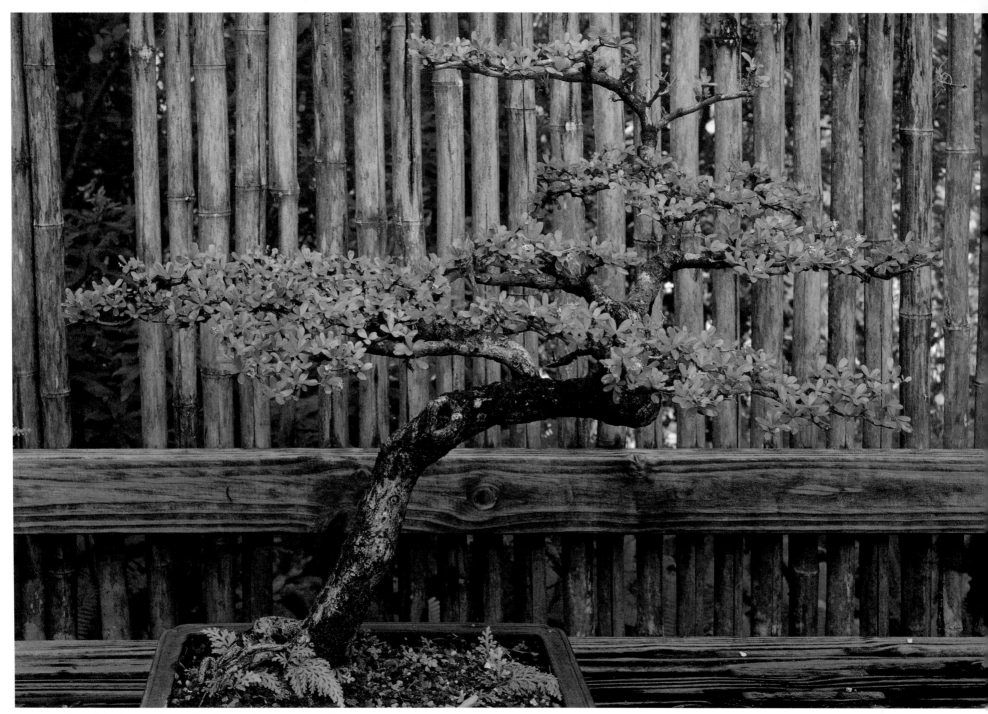

One of the bonzai for which the garden is renowned.

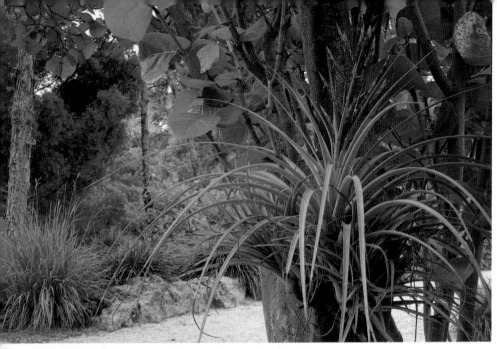

A blooming aroid along the stroll path.

color and exaggeration of the region's botany, this unique garden is intended to encourage an awareness of the *subtle* delights of nature.

Trees and plants have been selected for their branch patterns, leaf color, and texture. Different shades of green are juxtaposed. Natural stones, chosen for their color, texture, size, and sculptural quality and contrast to the delicacy of the foliage, are grouped asymmetrically in threes, fives, or sevens. Water, an integral element in the Japanese landscape, is used in ponds and streams both for visual and auditory effects.

The Morikami Garden was initially designed by Seishiro Tomioka, who served as superintendent of the Parks Planning and Design Division of the Palm Beach County Department of Parks and Recreation after receiving his degrees in landscape architecture in his native Japan.

56

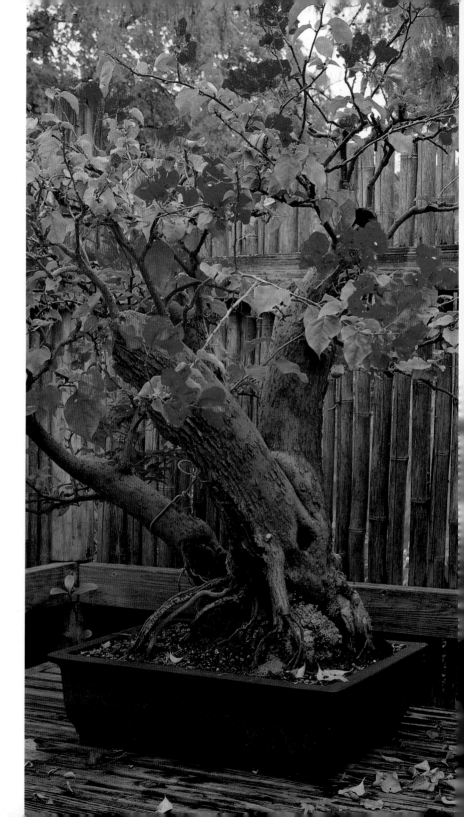

AT RIGHT:
A bonsai bougainvillea.

MOUNTS BOTANICAL GARDEN

West Palm Beach

A horticultural display and learning center, Mounts Botanical Garden was begun by a county extension agent so devoted to

BELOW:
A succulent in the dogbane family from Madagascar.

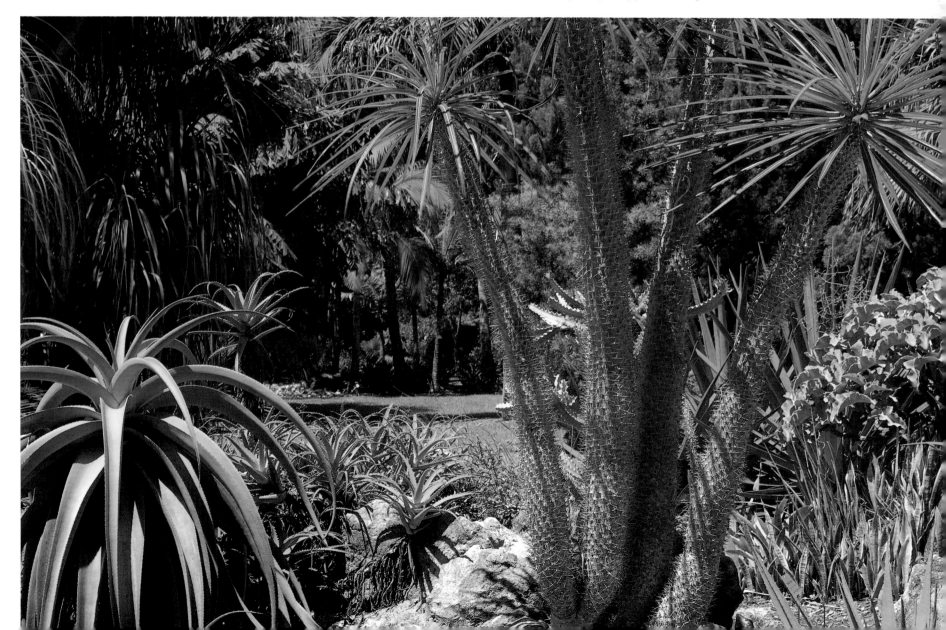

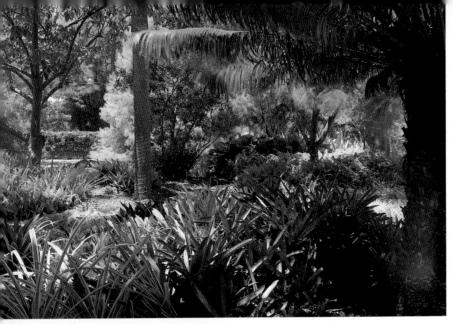

Assorted bromeliads and ferns serve as ground cover.

A cattleya hybrid orchid and monstera deliosa.

Towering native pine.

botany that this public garden was given his name. In 1954 Marvin "Red" Mounts planted the original specimens in what is today fourteen landscaped acres of rare trees and shrubs, sprawling gardens, and other horticultural collections. With a mission to promote "growing curiosity," the garden acts as a center for teaching, display, research, and conservation.

In the Xeriscape Garden, for example, visitors can observe plants ideal for the subtropical climate, requiring minimal water and care. Subtropical citrus, vegetables, palms, and shrubs are also showcased as a means of encouraging local gardeners to cultivate indigenous species that will thrive in their own back-yards. A Native Plant Collection and Palm Collection illustrate southern Florida's vast botanical diversity. A Hibiscus Garden, Rose Garden, and Vine Collection add floral color. In the fra-grant Herb Garden, Banana Collection, and Rare Fruit Collection, visitors can view an edible array of Florida plants. The Poisonous Plant Collection, on the other hand, is equally instructive.

Mounts Botanical Garden also includes a rainforest, a wet-land, and a cactus and succulent garden. Specialty displays, including insect exhibitions, are both ongoing and seasonal.

Ferns along the stone path.

THE SOCIETY
OF FOUR ARTS GARDEN

Palm Beach

Conceived as a devotion to art, literature, music, and drama, the Society of the Four Arts recalls the era in which Palm Beach saw the arrival of enormous wealth. Many of the country's most distinguished families made their winter sojourn south by private railcar, bringing with them their favorite paintings and other works of art. Surrounding themselves with their personal treasures allowed them to feel at home—and to impress their Palm Beach circle of friends and guests. Eventually, when the rigors of relentless entertaining and display grew too tiresome,

BELOW:
A view across the garden toward the museum.

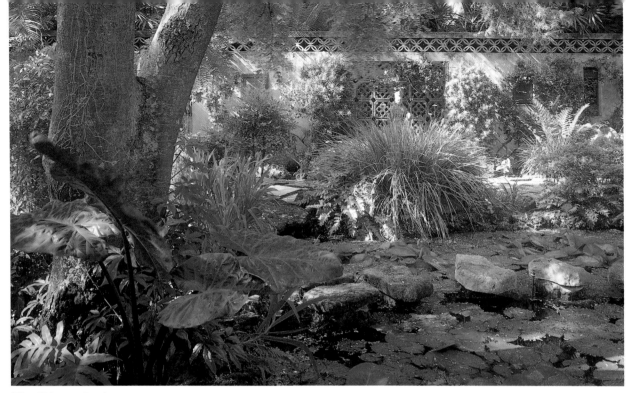

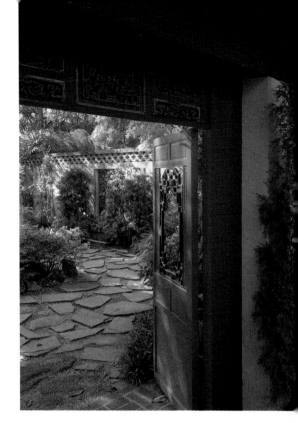

The Chinese Garden.

the idea of creating a central location where the community's works of art could be admired as an ensemble was born.

The first building, which housed the library, art galleries, and all cultural activities (and serves as the present library), was designed by the famed architect Maurice Fatio in 1938. In 1947 the Society purchased the Embassy Club, which was designed in the 1920s by the legendary society architect Addison Mizner, and it was remodeled to serve as the auditorium and gallery.

At the time the original building was being erected, a member of the Society conceived the idea of designing small individual gardens to demonstrate the variety of tropical plants suitable for the Palm Beach climate. Members of the Garden Club of Palm Beach created a Chinese Garden, a Jungle Garden, a Spanish Facade, a Bermuda-style English Garden, a Moonlight Garden, a Tropical Fruit Garden, and a Rose Garden.

Today, although somewhat different in design, these gardens continue to delight. The Chinese Garden is accented by moon-gates or openings in the walls of various shapes and sizes. Carved on the lintel of the red and blue entrance is a Chinese phrase which translates to "Garden of Happiness and Harmony." A pair of ceramic Fu dogs guards the gates against evil spirits while statues of Buddhist and Taoist divinities add their blessings to the scene. The plants selected for this garden are either native to China or compatible Florida natives. A red sandalwood weeps over a pond studded with white waterlilies, spiceberry and polyantha roses nestle among the rocks, jasmine climbs the wall. A variety of junipers, pines, and bamboo frame the sculpture, while pomegranates, purple taro, blackberry lilies, and brilliant splashes of azaleas add color.

The Spanish Garden features a magnificent sausage tree with giant-leafed ceriman clinging to its trunk and lacy tree philo-dendron at its base.

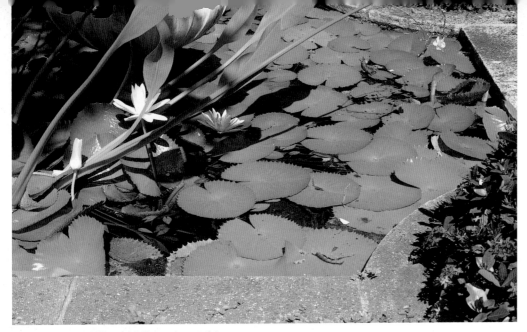

Tropical water lilies and flowering red ixora.

Bronze sculpture entitled Reaching *by Edward Fenno Hoffman III.*

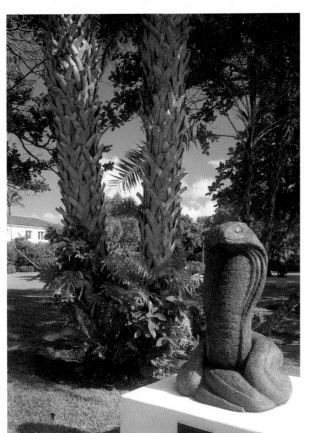

In what is now known as the Madonna Garden, Surinam cherry, oleander, and jasmine lead to a formal fountain and shrine to the Madonna, framed by an orchid tree and angel's trumpet with elegant, long trumpet-shaped blossoms.

The Moonlight Garden, as its name implies, is filled with highly scented, night-blooming flowers that can be seen and smelled at night, such as pink shell ginger lilies and white hibiscus.

The formal Rose Garden fills the sunny corners around the patio of the library, where a small herb garden is also planted. The paths leading from one garden to another are composed of stone tile, patterned from coral fossils, made from the limestone of reefs. The sculptures sited throughout the Society of the Four Arts and in its Sculpture Garden exhibit a range of styles, from the classical representations of the four seasons to the twenty-foot-high stainless steel pyramid by Isamu Noguchi.

AT LEFT:
A bronze serpent entitled Naja *by Diana Guest.*

62

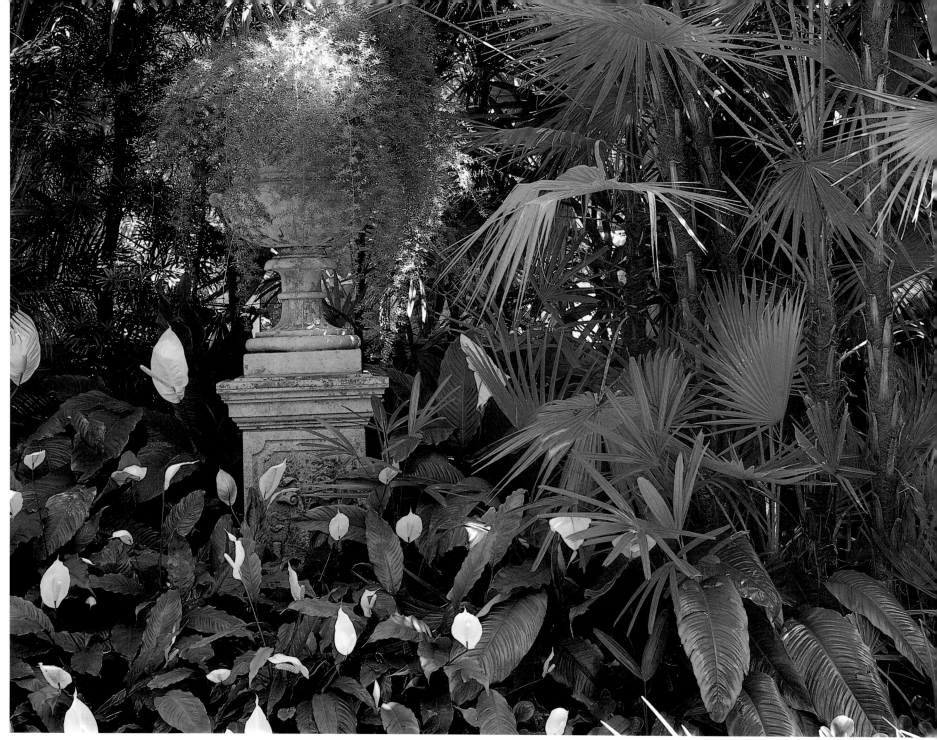

White spathiphylla blooms.

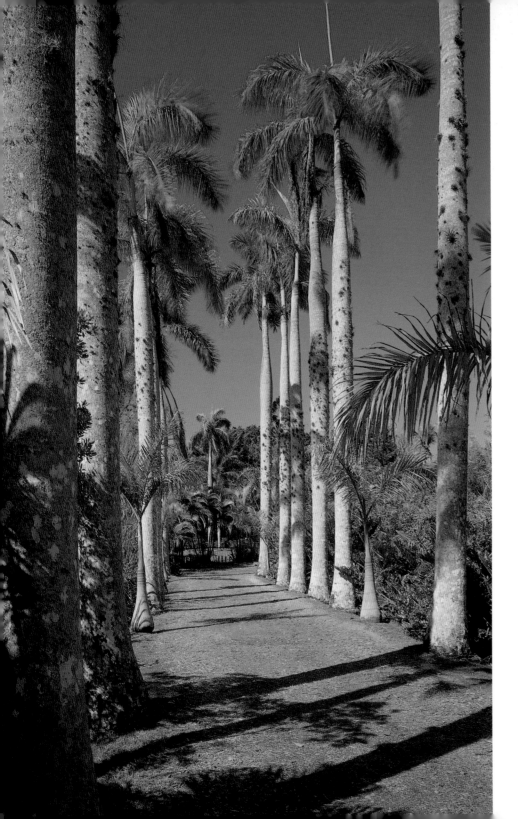

CARIBBEAN GARDENS

Naples

Within the heart of Naples, in a tropical rain forest replete with thousands of species of exotic flora, lives a world of birds, monkeys, reptiles, and such "big cats" as the clouded leopard and the Bengal tiger. These plants and animals grow within a fifty-two-acre botanical and zoological preserve known as Caribbean Gardens.

The garden is the product of three visionary men who never even met one another. In 1919, the first, botanist Dr. Henry Nehrling, conceived of a facility where rare plants from all over the world could be cultivated in a Florida setting. By 1925 his botanical collection exceeded 3,000 specimens. After his death in 1929, the garden fell into a two-decades-long state of benign neglect.

Hidden under a dense, entangled labyrinth of unrestrained native growth, the garden was rediscovered in the early 1950s by Julius Fleischmann, who was determined to expand on his predecessor's dream. Fleischmann nourished the existing flora and added new species. He then created two large lakes, walking trails, and a pavilion where visitors to the garden could enjoy entertainments. By 1954 he was ready to open the newly named Caribbean Gardens. The romance and tranquillity of the lush setting quickly attracted visitors from across the country.

After Fleischmann's death, the trustees of his estate, seeking to enlarge public interest in the Gardens, contacted the world-traveled expedition leader Colonel Lawrence Tetzlaff. Colonel Tezlaff, known as "Jungle Larry," and his wife, "Safari Jane," had traveled to such remote locations as West Africa, the Australian outback, the rainforests of Brazil, and the jungles of Guyana, and brought back endangered wild animals along with film footage showing how the animals lived in their natural habitats. Convinced that the Caribbean Gardens would make an ideal North American home for his collection of jungle creatures,

An allée of royal palms.

Florida deer grazing.

A cattleya hybrid orchid.

Colonel Tezlaff agreed to relocate them here. The temperate climate provided an ideal breeding ground for many of his rare species.

Today, Caribbean Gardens celebrates the devotion and far-sightedness of its creators with expanded exhibits of flora and fauna as well as with ongoing educational programs. The Guided Primate Expedition, for example, introduces visitors to lemurs, monkeys, and apes residing on an island first created by Julius Fleischmann. Colonel Tetzlaff's passion for education and first-hand experience is sustained through the Scales and Tails Show. In the Big Cat Performance, his son, David, interacts directly with leopards and Bengal tigers while lecturing on the environmental issues affecting these animals in the wild. The "Meet the Keeper" series is designed to give visitors the opportunity to speak with the animals' caretakers while observing them in their habitats.

The Caribbean Gardens has grown far beyond Dr. Nehrling's original dream. Today, the vegetation he began cultivating more than seventy-five years ago offers visitors a beautiful setting in which to learn about botanical and animal life.

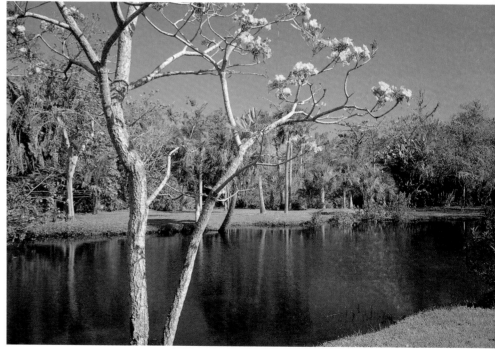

A tabebuia tree in bloom.

A magnificent red bougainvillea in front of the Edison house and guesthouse.

THOMAS EDISON
WINTER ESTATE GARDEN

Ft. Myers

Like countless others who have come to Florida on vacation, one of the most prolific inventors in the history of the United States, Thomas Alva Edison, was so taken with the tropical setting that he purchased real estate and built himself a winter home. In 1885 he chose fourteen acres on the bamboo-lined shores of the Caloosahatchee River in what was then the village of Ft. Myers. "There is only one Fort Myers, and ninety million people are going to find out about it," he declared. On the site, he constructed not only a house with a huge breezeway, large porches, and detached kitchen (he detested the smell of cooking), but also the laboratory in which he developed the giant fourteen-foot-tall strain of the goldenrod weed that would become the nation's critical source of rubber.

A crinum lily and a stand of towering bamboo.

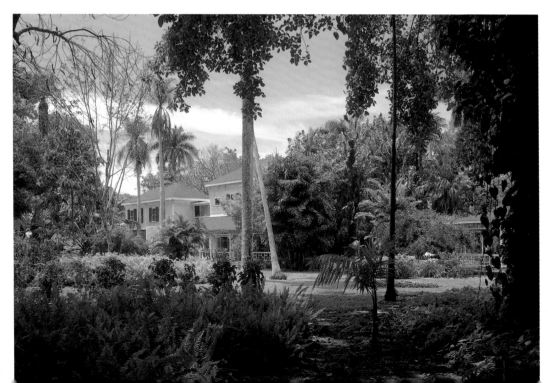

The house and its detached kitchen.

67

A cycad, one of the oldest botanical species in existence.

Firecracker ferns and aged bamboo.

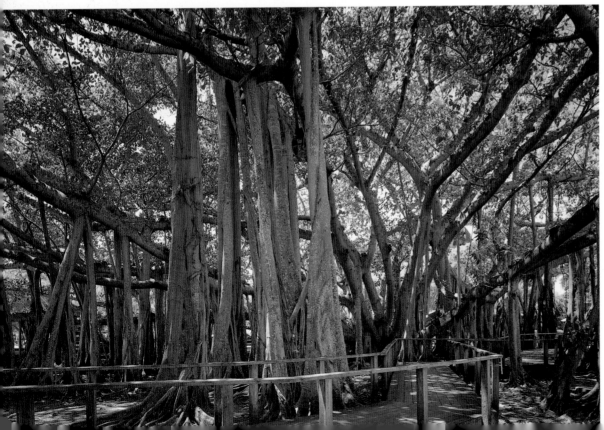

The sprawling banyan tree, reaching more than 400 feet in circumference.

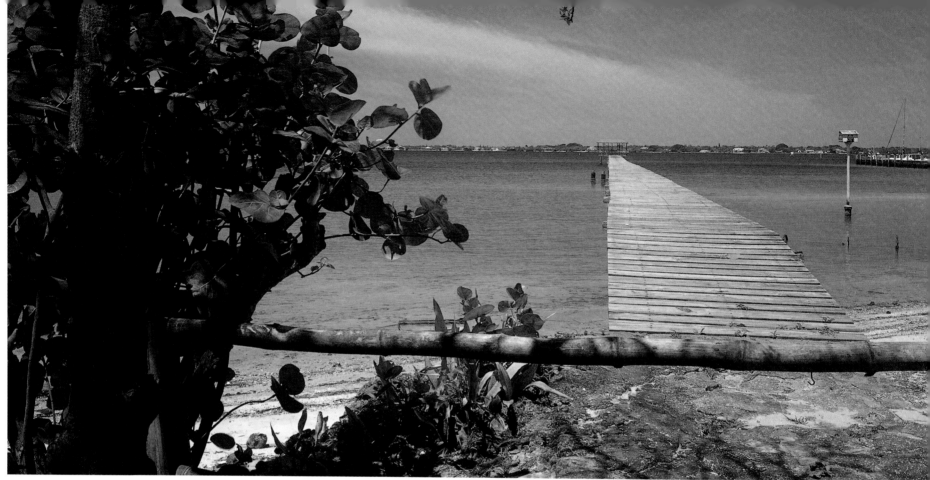

The boardwalk leading out to the Gulf of Mexico.

Edison was a master horticulturist. Giant trees, brilliant flowering vines, and graceful palms flourished under his care. The dramatic example of his expertise is the banyan tree brought from India by Harvey Firestone. It measured two inches in diameter when Edison first planted it in 1925. Today it reaches more than 400 feet around the trunk.

Edison's tropical botanical garden, planted more for its experimental value than for beauty, is one of the most complete in America. It contains more than a thousand varieties of plants—tropical and subtropical fruits, flowers, trees, and vines—imported from all over the world. Among the most exotic are a South African sausage tree with enormous eight-to-ten-pound pods and red flowers, an African pin cushion tree with edible fruit, a Himalayan Herald's Trumpet with a white Easter lily vine, and a Chinese cinnamon tree with edible bark.

Edison's house and laboratory have been preserved exactly as he left them, as has the house on the adjoining estate built in 1916 by his close friend Henry Ford. A 7,500-square-foot museum, built by Edison's son Charles, exhibits memorabilia related to the inventor's life, including a Model T Ford presented to him by Mr. Ford.

The Selby House.

MARIE SELBY
BOTANICAL GARDENS

Sarasota

The only botanical garden in the world to specialize in epiphytes—or air plants such as orchids—this tropical haven provides a nine-acre open-air stage for more than 20,000 plants, including orchids, flowers, cacti, and cycads. The outstanding collection of air plants, which attach themselves to other species without doing harm to their hosts, includes many rare and endangered varieties.

Both a living outdoor and under-glass museum, Selby

The Cactus and Succulent Garden.

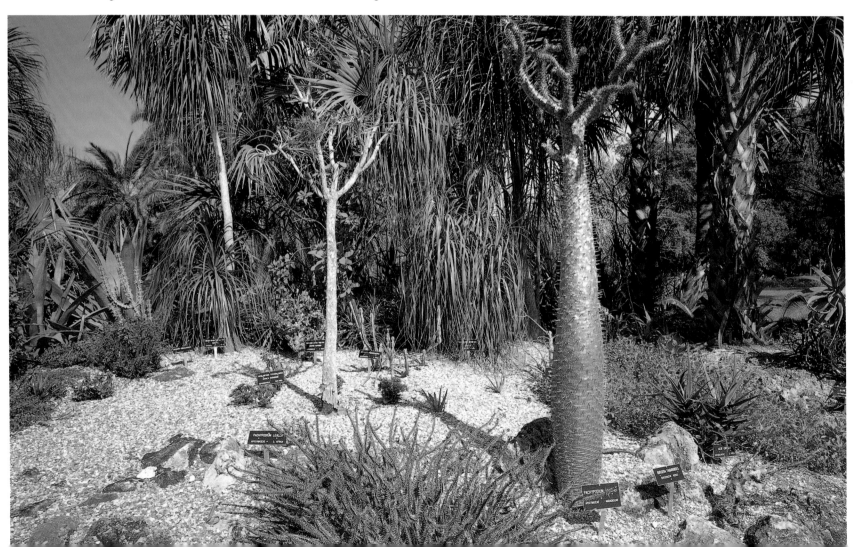

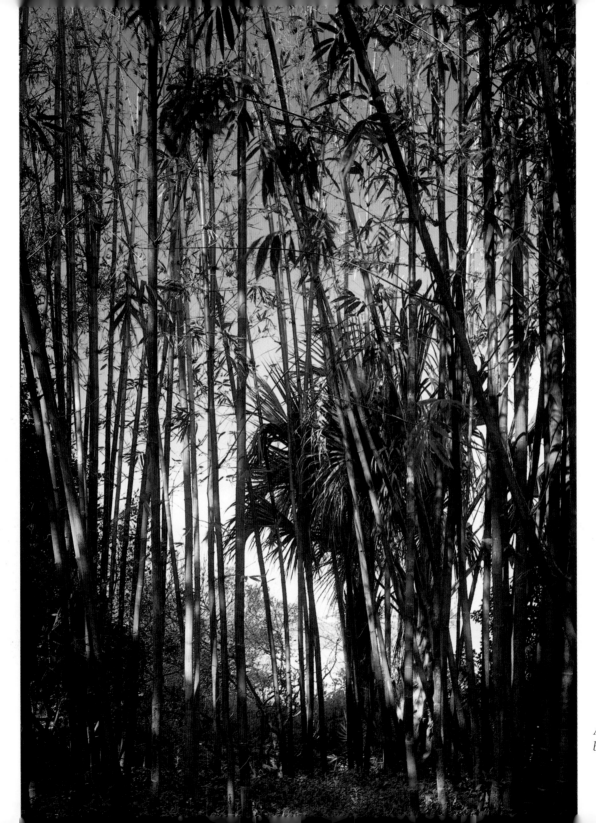

A stand of slender bamboo.

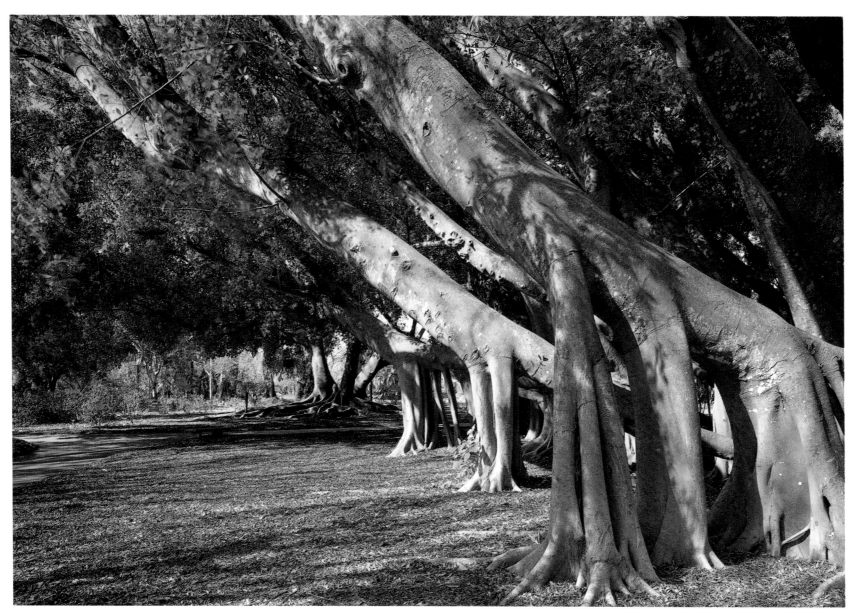

Dinosaur-like ficus tower over the walkway.

AT LEFT AND ABOVE:
Orchid-laden paths in the greenhouse.

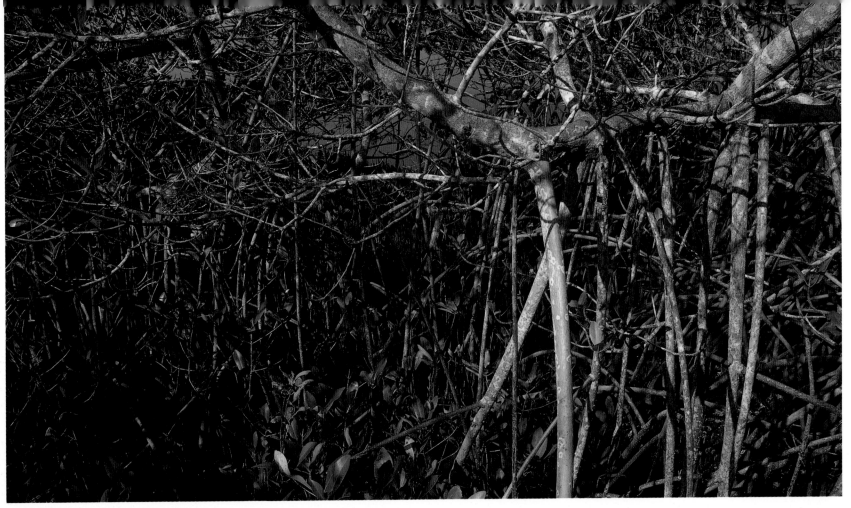

Dense mangroves at the water's edge.

includes a live oak grove, a banyan grove, and a 6,000-square-foot display greenhouse with walkways winding through a jungle rainforest. In the waterfall garden, angel's trumpet flowers cascade above a lily pond inhabited by brilliant orange Japanese carp, known as koi.

The garden was a gift to the city of Sarasota from amateur horticulturist Marie Selby, widow of oil magnate and philanthropist William Selby. It was opened in 1975. Its world-recognized team of botanists and horticulturists, in conjunction with 600 volunteer workers, cultivates the site's Cactus and Succulent Garden, Cycad Collection, Fernery, Hibiscus Garden, Palm Grove, Bamboo Pavilion, Tropical Food Garden, Butterfly Garden, and Perennial Wildflower Garden. Behind the scenes of this flowering display, Selby's scientists are exploring the secrets of these tropical plants.

The Museum and Learning Center provide additional educational opportunity. The Museum building, formerly a classic southern mansion, houses botanical art and photography from throughout the U.S.

BUSCH GARDENS

Tampa

BELOW:
Multicolored impatiens, ferns, cycads, and philodendrons provide rich ground cover.

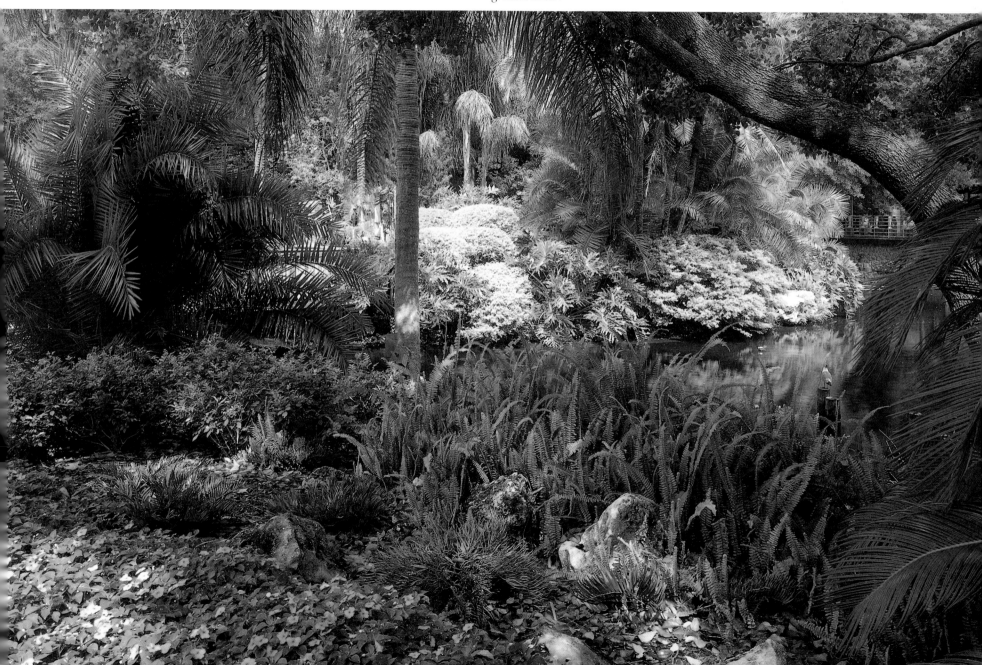

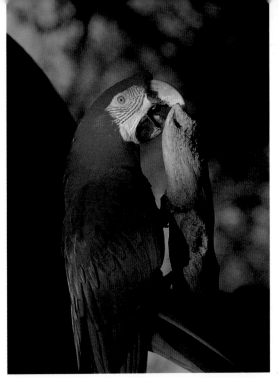

A macaw.

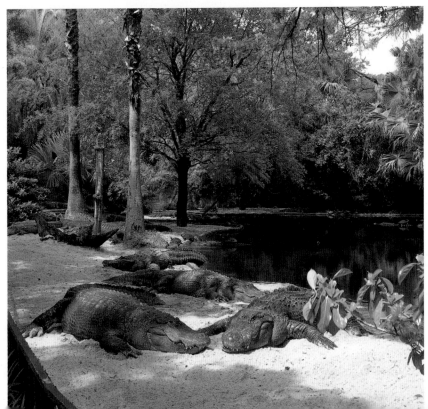

Alligators.

Flamingoes.

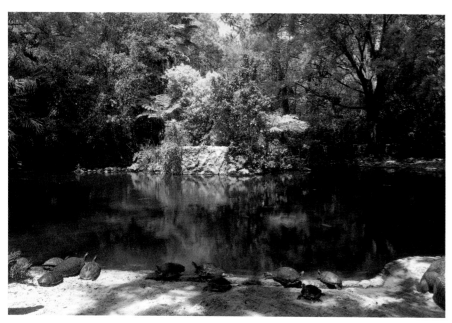

ABOVE AND BELOW:
Turtles and egrets bask at the waterside.

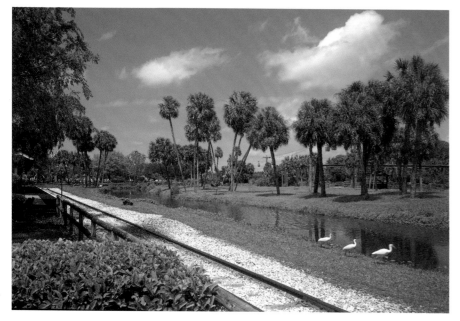

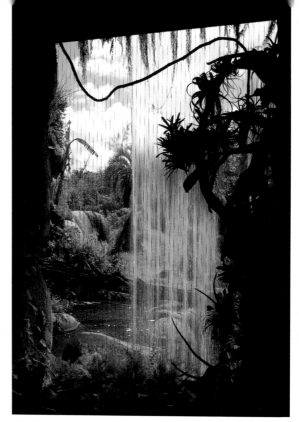

A view of the waterfall from inside the "cave" with bromeliads in silhouette.

The African continent is the botanical and zoological theme of Busch Gardens' 335-acre park. Its landscape ranges from such open vistas as the sixty-acre natural grass veldt in the Serengeti habitat to the rugged terrain of the three-acre Myombe Reserve where chimpanzees and gorillas make their homes amid dense vegetation and waterfalls. In the Great Ape Domain grow the Chinese Parasol tree, banana trees, and plants known as "flamingo flowers."

Established in 1959 as the Anheuser-Busch Tampa brewery, the original beer-making facility was surrounded by beautiful gardens where trained birds performed for the amusement of visitors. Throughout the next three decades, these gardens were expanded to become one of this country's premier zoos, featuring more than 2,800 animals and a breeding program for endangered species.

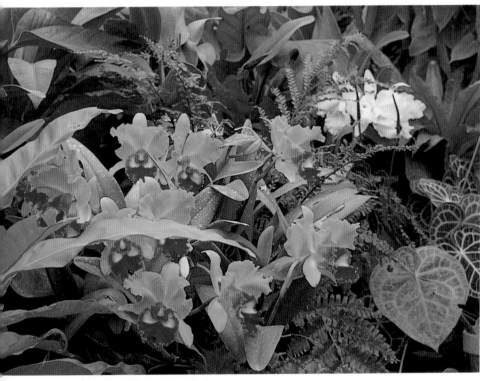

Cattleya hybrid orchids.

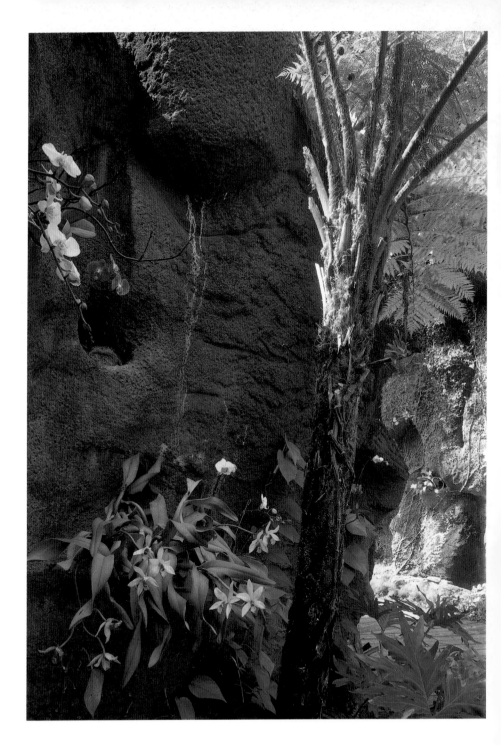

A tree fern and white phalenopsis orchid.

A vivid display of bougainvillea.

While the focus of Busch Gardens is its animal life and amusements, the botanical displays are designed to give visitors a first-hand feel of the sensations of the African terrain. Collections of palms, orchids, vines, enormous tree ferns, monstera deliosa, and native hardwoods such as mahogany and oak bring into rich dimension the exotic density of an African jungle. "Orchid Canyon," for example, features five different genus of this epiphyte among the several hundred that flourish on the site. The Serengeti Plains, on the other hand, features wide expanses of grasses punctuated by oak trees trimmed as if they have been foraged by wild animals. Even the children's play area of the park, known as the Land of the Dragons, has been uniquely landscaped—its vegetation derives from the northern latitudes and includes Weeping Blue Deodara Cedars native to the Himalayas and Canadian Redbuds.

All vegetation and foliage within Busch Gardens' animal habitats are researched and tested to ensure that their proximity to the animals is entirely safe.

AT RIGHT:
Purple cattleya and white phalenopsis orchids at the waterfall.

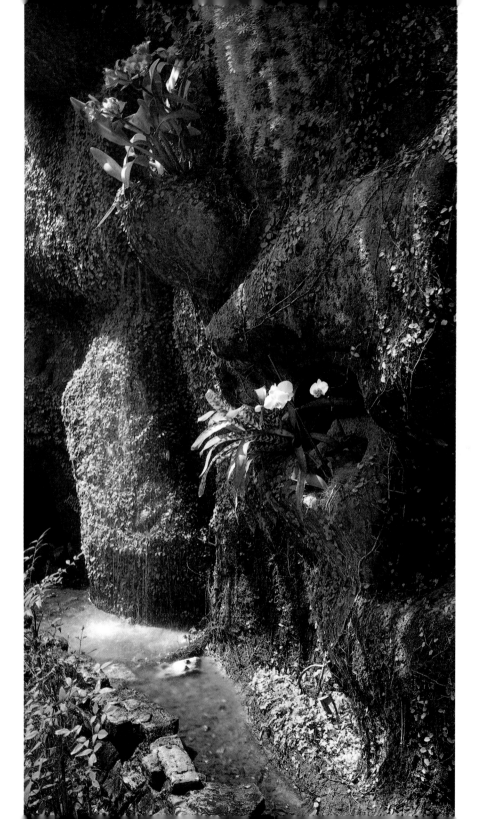

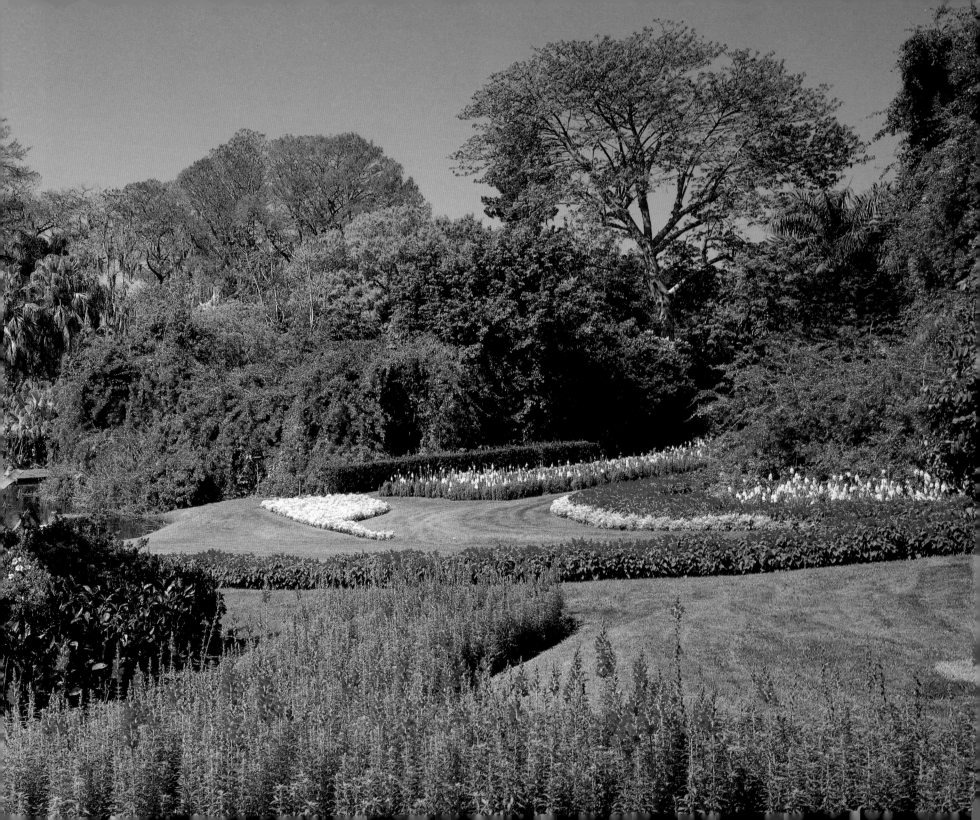

CYPRESS GARDENS

Winter Haven

Central Florida's first tourist attraction, Cypress Gardens, was born—in 1936—of one man's desire to lure tourists into a botanical wonderland and intoxicate them. Dick Pope, the son of a real estate broker, and a relentless promoter, was known variously as the "Barnum of Botany" and "Swami of the Swamp." After reading an article in *Good Housekeeping* about a man who had opened his home to the public and charged admission, Pope and his wife returned to Winter Haven, where he had spent his teen years. They determined to turn sixteen acres of useless swampland into a botanical paradise on the shores of Lake Eloise.

Deep-colored crotons, in foreground, contrast against a variety of ferns.

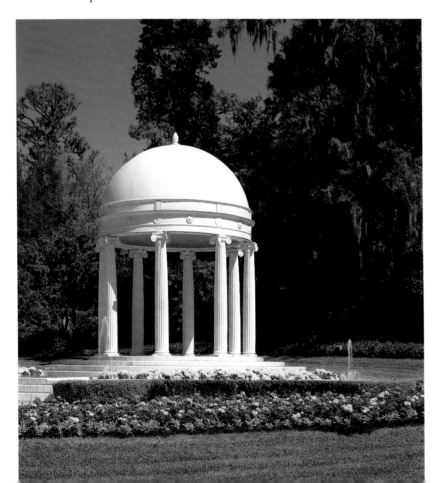

The press ridiculed Pope's dream up until the day of its opening, when suddenly he became "Mr. Florida—the first citizen of the State." Despite having to travel on a dirt road from Haines City (until 1947), tourists were magnetized by Pope's publicity and flocked to what he called the "World's Foremost Tropical Showplace." To draw the gentlemen to his showplace, Pope staged annual beauty pageants in the name of every flower grown in the garden—eventually more than 100 a year. In time Cypress Gardens' success led Pope to become known as "the Father of Florida Tourism."

In 1943, a photograph of the garden showing water-skiers being pulled behind a boat appeared in a local newspaper and drew several soldiers based in the area to come see the "water show." Pressed to produce an attraction that didn't exist, Julie, Pope's wife who was running the park while her husband was

OPPOSITE PAGE:
Cascades of bromeliads frame beds of vivid annuals.

AT LEFT:
The gazebo, a favorite site for weddings.

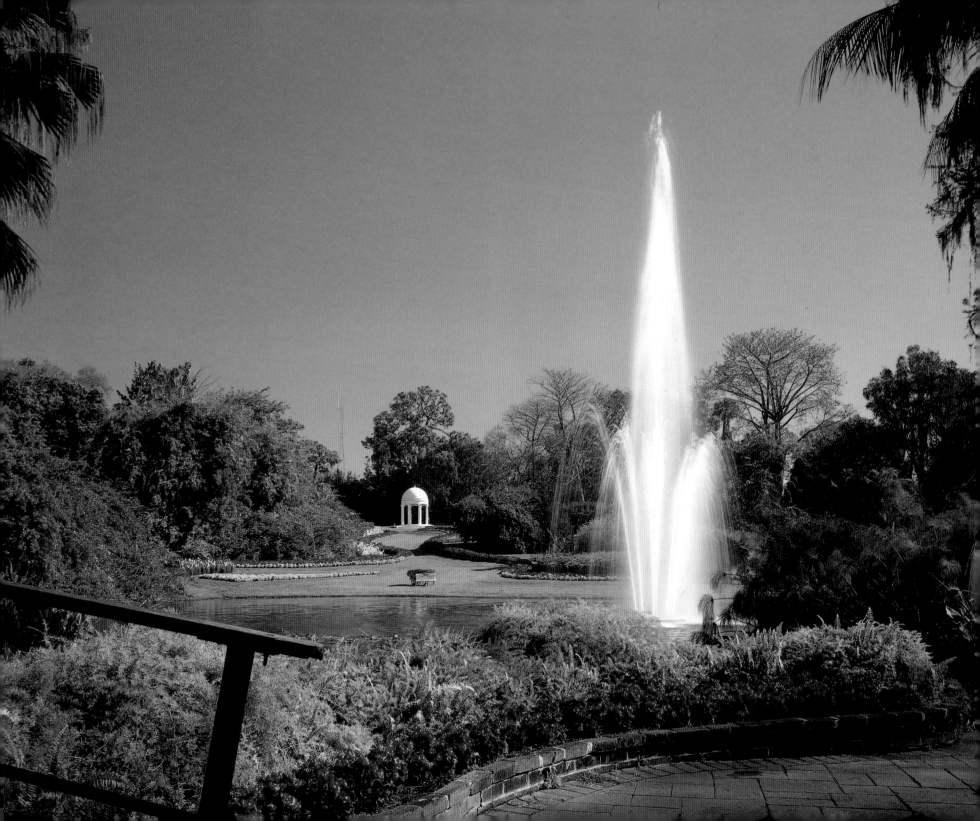

ABOVE AND BELOW:
A stand of bald cypress hung with Spanish moss.

AT LEFT:
*Vista with begonias and ferns
in foreground.*

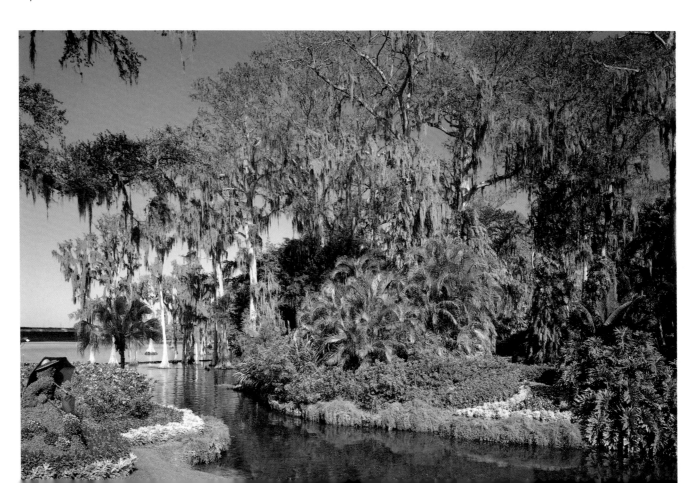

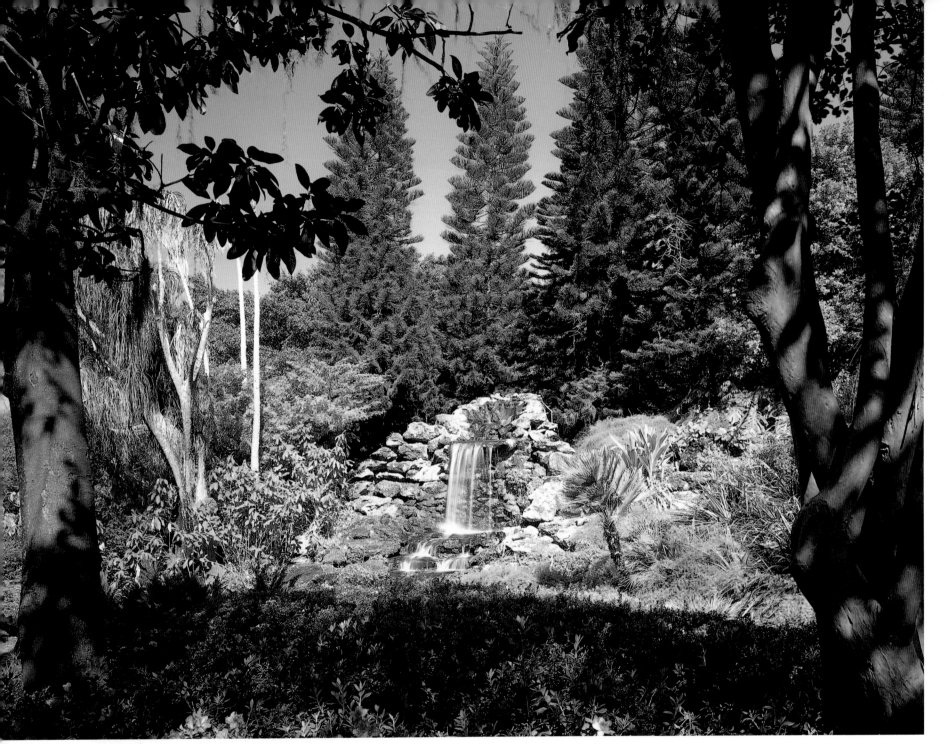

Mediterranean waterfall with ponytail palm at left.

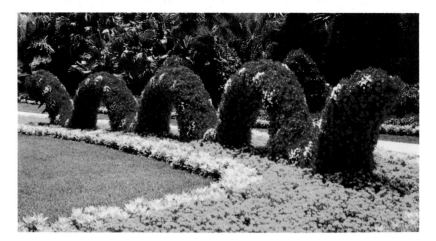

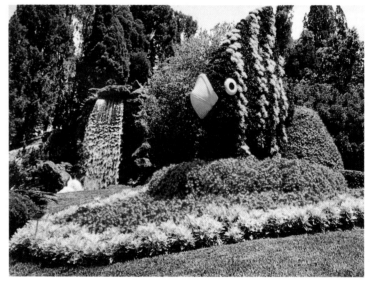

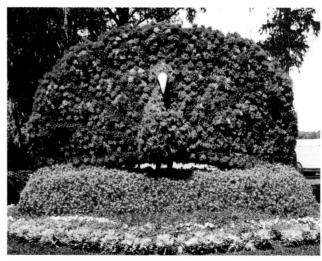

More than thirty thousand marigolds, begonias, impatiens, red salvias, blue ageratum, and silver "dusty" millers comprise the larger-than-life blooming topiaries created for each year's Spring Flower Festival, March 15-May 15.

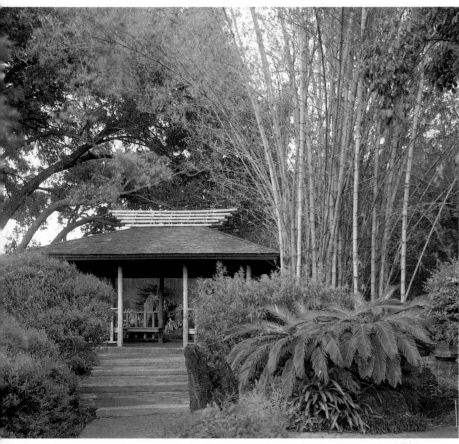

Towering bamboo and a monumental Buddha in the Oriental Garden.

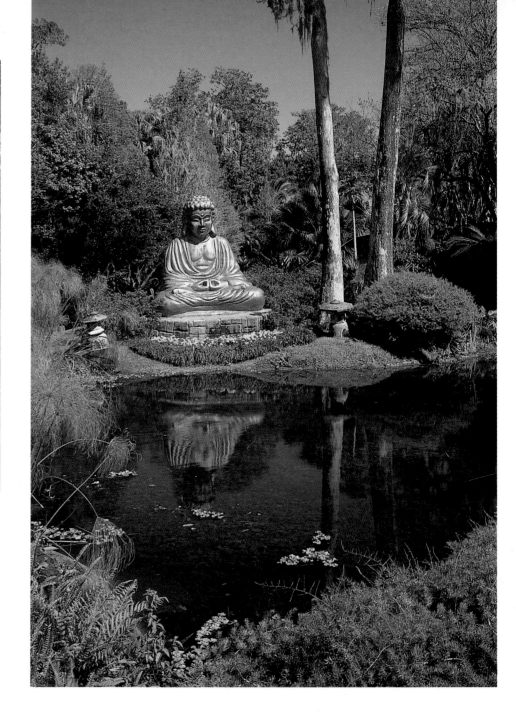

OPPOSITE PAGE:
A bridge traverses one of the gardens' waterways.

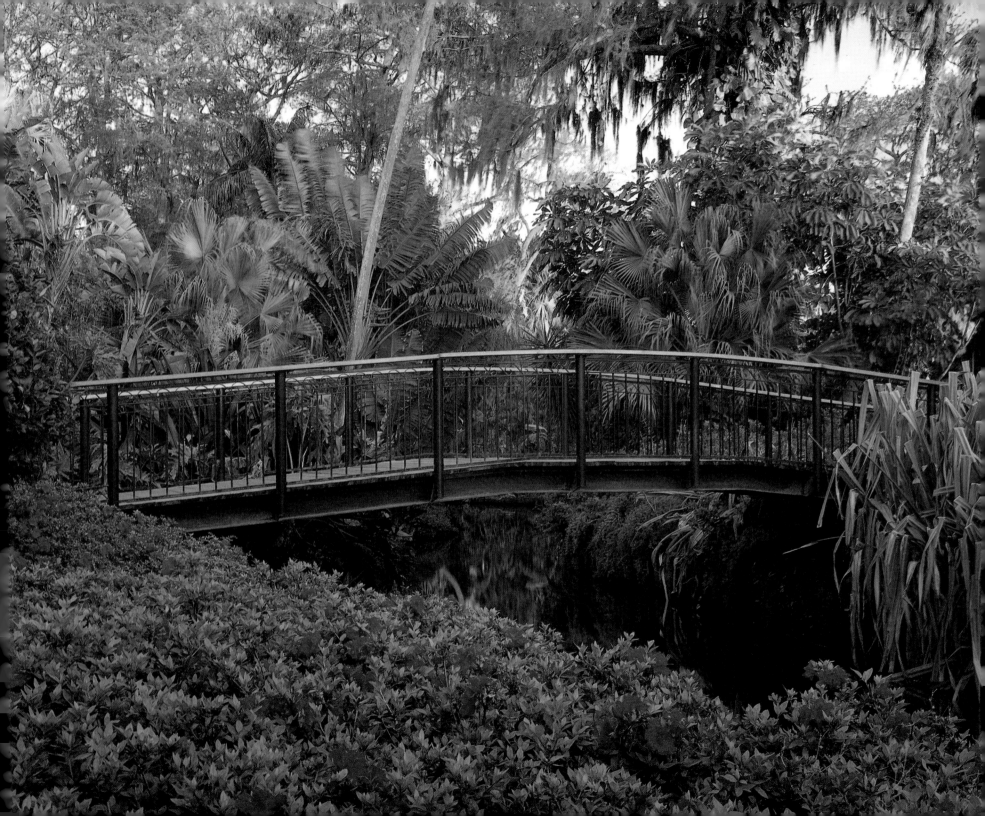

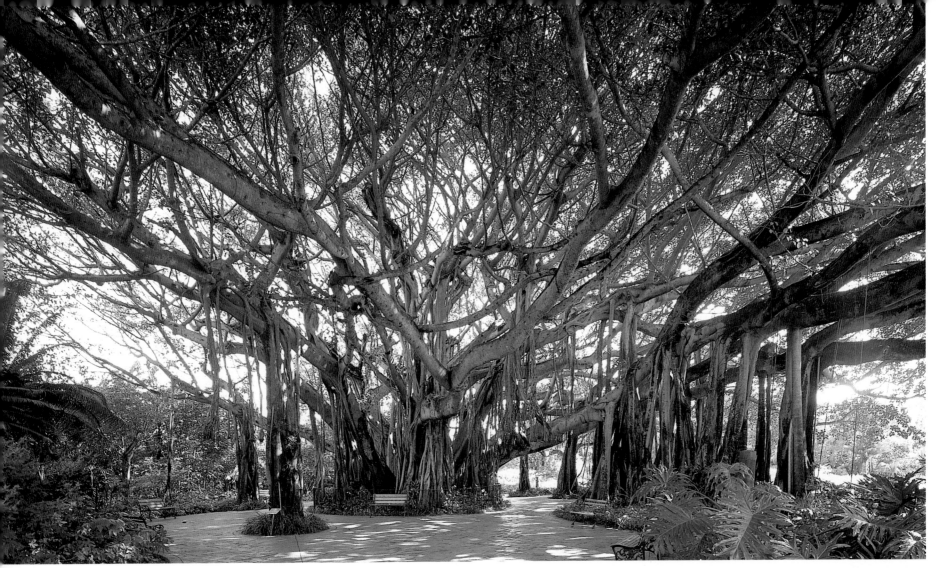

The sprawling banyan tree.

serving in World War II, improvised a water-ski act with her children and their friends. The next weekend 800 soldiers showed up, and the Cypress Gardens' regular water-ski show was born. (Today it is the longest continuously running entertainment production in the world).

In time the Popes added more property and more attractions, including boat tours, fireworks displays, and, most famous of all, the smiling, waving, floral-enshrined Southern Belles in their billowing antebellum-style gowns. Today each Cypress Garden belle has her picture taken an average of 500 times a day.

Eventually Cypress Gardens grew to 200 acres with 8,000 varieties of tropical and subtropical plants and flowers from all over the world.

SLOCUM WATER GARDENS

Winter Haven

Unique in its single botanical focus, Slocum Water Gardens specializes in the culture of water lilies. This aquatic flower is the showpiece of water gardening. The largest and showiest of this species are the tropical varieties, which are both day and night blooming. Floating high above the surface of the water, each bloom flowers for up to five days at a time, adding color and patterning to the overall design of the garden. The palette of these flowers ranges from autumn shades to greens, blues, pinks, and classic white.

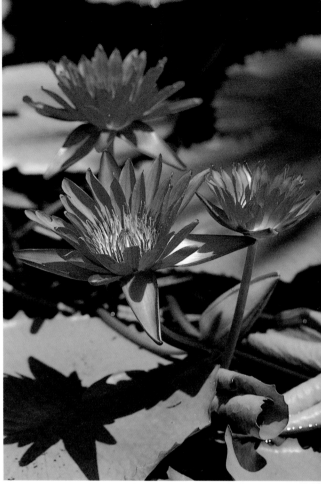

Detail of purple-bloomed tropical water lilies.

AT LEFT:
Amazon giant water lilies, over two feet in diameter.

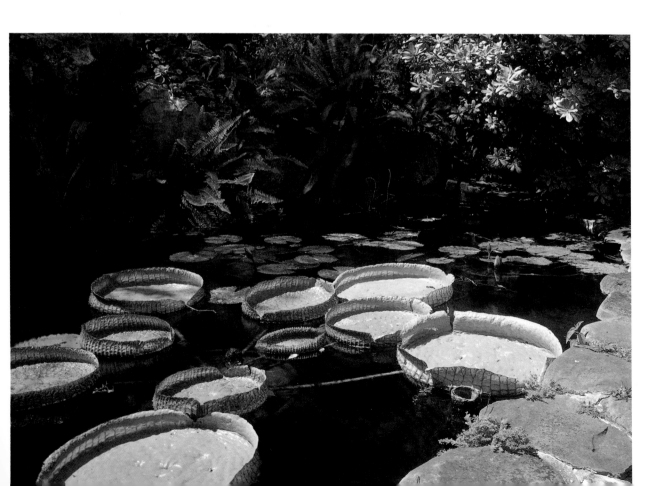

91

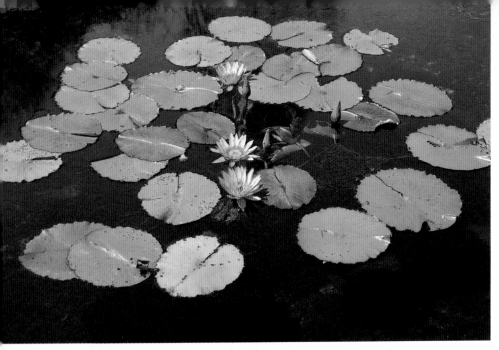

Tropical water lilies with pink blooms.

In addition to varieties of water lilies, Slocum Water Gardens showcases other aquatic plants such as lotus flowers, as well as fish, fountains, and a waterfall. A continuous enterprise since 1938, the garden is situated alongside a major highway, making it a convenient source of aquatic gardening ideas and supplies. In addition to the plants and fish that can be purchased here, a complete line of water gardening hardware is available, including pool liners, pumps, and lighting.

Bridges in the garden are local landmarks.

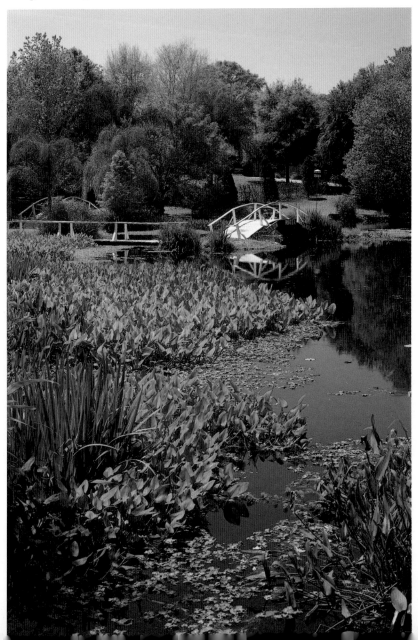

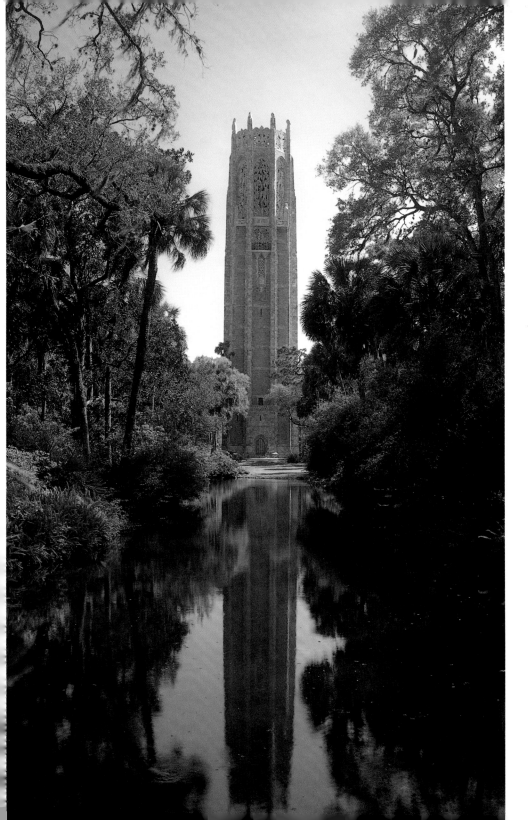

BOK TOWER GARDENS

Lake Wales

Bok Tower Gardens is a botanical meditation on the art of tranquillity. Its 157 acres of plants, flowers, and mature trees provide a park-like sanctuary for birdlife and wildlife, as well as for the carillon, a fifty-seven-bell instrument that rings out a daily serenade. Dedicated in 1929 by President Calvin Coolidge, the Singing Tower and the Mountain Lake Sanctuary, as they were then known, were the gifts of Dutch philanthropist and editor of *Ladies' Home Journal* Edward W. Bok.

In 1923 Bok chose the highest point on the Florida peninsula, then a sandy hill of ferrous rock covered with pines and scrub palmettos, as the site for his garden of profound repose. He invited the landscape architect Frederick Law Olmstead, Jr., son of the illustrious designer of New York's Central Park, to plan the elegiac setting. As work progressed, Bok decided to add a carillon tower like the ones he remembered from his boyhood in the Netherlands.

The visual introduction to the sanctuary begins from miles away with the image of Bok Tower rising 205 feet over the vista of orange groves that comprise the approach. From the entrance, bark-mulched paths wind through expanses of lawn and a canopy of live oaks draped with Spanish moss. Fragrant plantings of camellias, gardenias, magnolias, azaleas and other flowering

AT LEFT AND ON FOLLOWING PAGE:
The garden and its reflecting pool provide sanctuary to water fowl and wildlife.

93

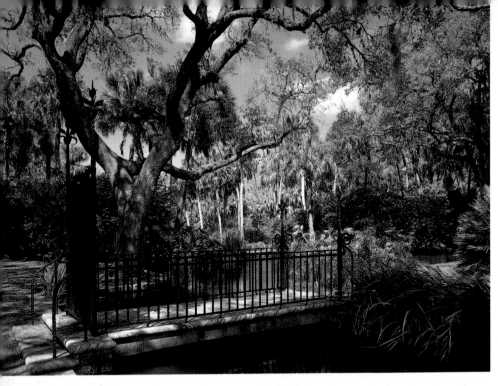
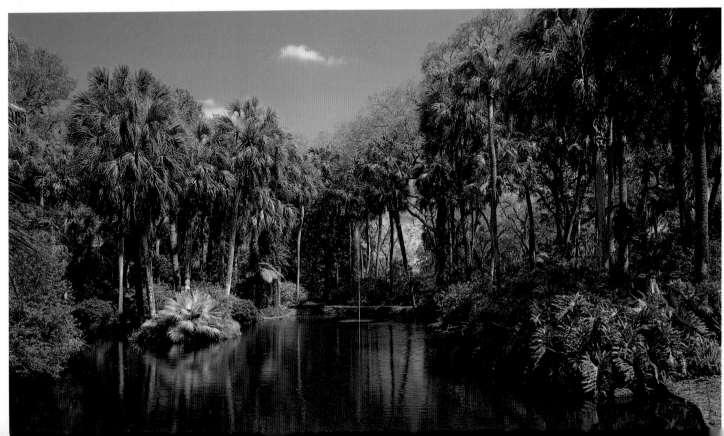

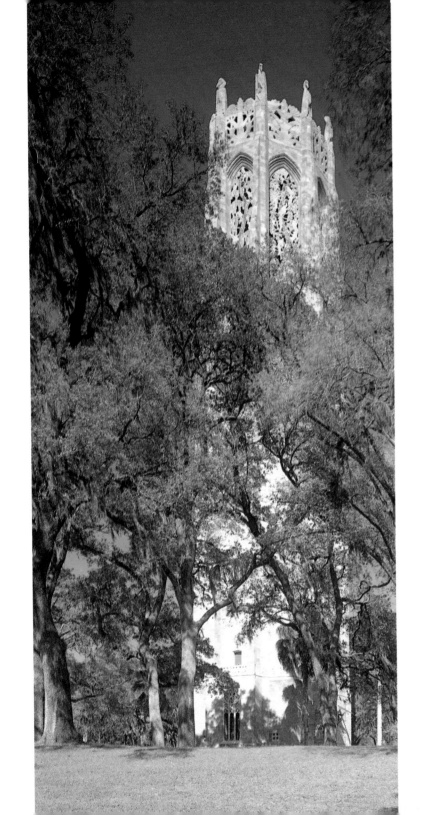

The stone heron sculptures at the top of the tower and the frieze of Florida wildlife were designed by Lee Lawrie. The colored tile grilles were produced by the Enfield Pottery. The wrought iron and thirty-paneled brass door are the work of the master metalworker Samuel Yellin, who also produced the gates of Miami's Villa Vizcaya.

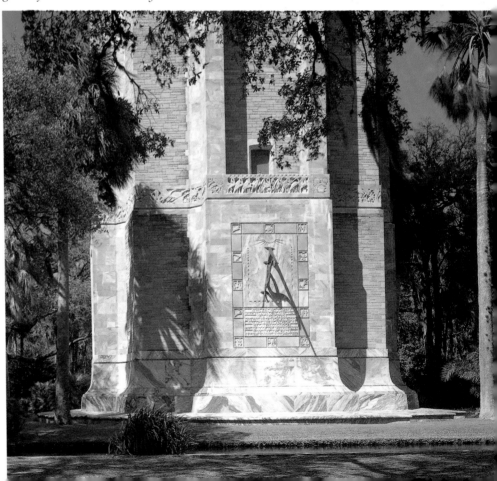

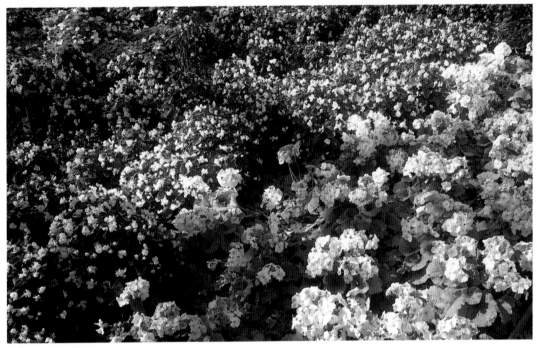

White geraniums in bloom.

plants punctuate the deep green view of ferns, palms, oaks, and pines. In addition to native and exotic plants, trees, and flowers, more than 120 species of wild birds make this garden their home.

At the top of the hill to which the garden rises is the Lake Pierce Vista which looks down upon the Pine Ridge Nature Preserve, land that, half a million years ago, was part of the ocean floor. Today it—and the garden sanctuary—is inhabited by such nocturnal creatures as bobcats, foxes, raccoons, armadillos, and opossums. An excedra, or semicircular conversation seat, provides a classical setting for contemplating the view.

An impressionistic image of the Singing Tower shimmers in the mirror of the Reflection Pool where swans and brilliantly feathered wood ducks bathe and swim. The tower, a vision of grace made from pink Georgia marble and Florida coquina stone, was designed by Milton B. Medary, who combined Gothic architectural devices with Art Deco decoration. The contours of the tower base suggest the profile of a bell. Faience grilles within the Gothic arched windows and the frieze forming a parapet depict Florida botany and wildlife. The wrought iron work and thirty-paneled brass door illustrate the story of the Creation. Colorful, fanciful, and classically proportioned, the Tower stands beyond the pool on a small island surrounded by a moat and iron gates.

The carillon music emanating from the Singing Tower is, of course, the most unique element of the Garden. The bronze bells, pealing from the tower's highest floors, range in sound from that of a solo voice to a quartet to a small orchestra to the all-encompassing crescendo of a symphony. The luxuriance of the music, in concert with the landscape, is embraced by and amplifies the surrounding beauty.

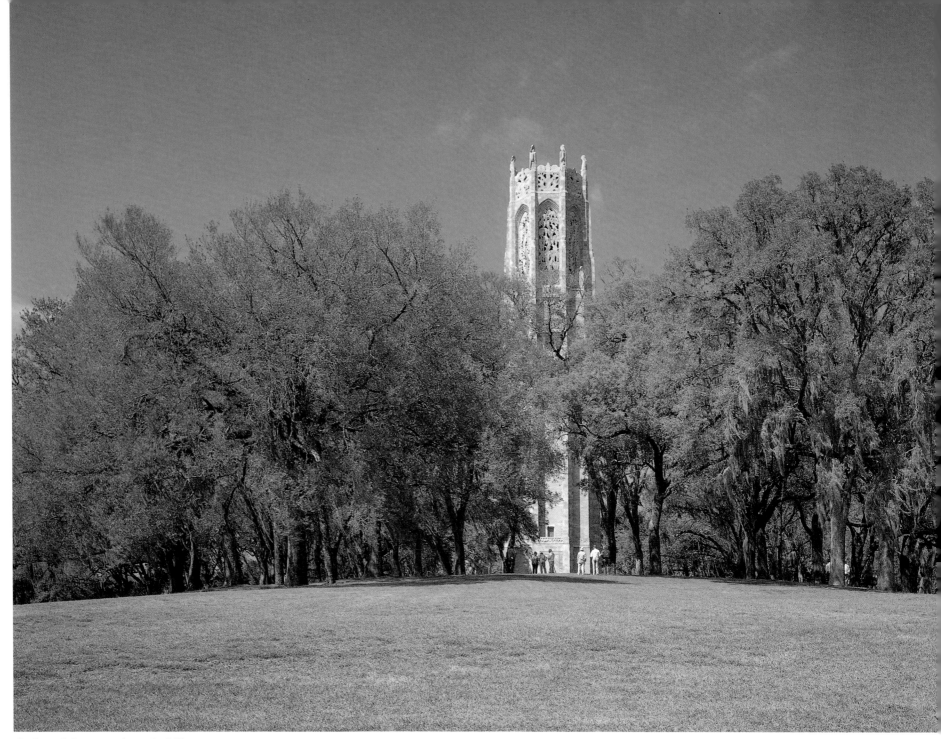

A view of the tower from the hill.

HARRY P. LEU GARDENS

Orlando

The Harry P. Leu Gardens is one of the few public gardens *anywhere* where visitors are actually *invited* to walk on the grass. Its "Old Florida" ambience makes leisurely strolling through the setting's fifty acres a wholly fulfilling occupation.

Harry P. Leu, a local businessman, and his wife, Mary Jane, traveled the world collecting plants. After twenty-five years they had transformed their estate, located on the shores of Orlando's Lake Rowena, into a showplace. They donated their

Spanish moss adds to the garden's old Southern charm.

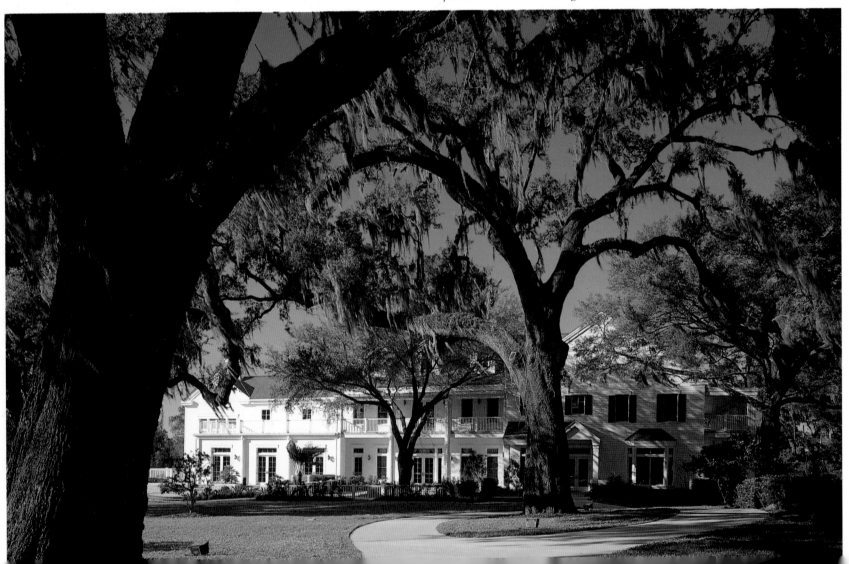

Camellias, pansies, and begonias enliven the garden with seasonal color.

home and its surrounding gardens to the city of Orlando in 1961.

Today, nestled in a forest of towering oaks, are over two thousand specimens of camellias that bloom from October through March. The flowers comprise the largest documented camellia collection in eastern North America. In addition to this stunning Camellia Collection, the garden includes two woods, a ravine garden, a conservatory, a xerophyte garden, a white garden, a rose garden, a palm garden, an overlook, and the Leus' house, which has been restored and is listed on the National Historical Register. The woods, known as the North and South woods, are actually a forest with a closed canopy of live oak, laurel oak, longleaf pine, and several species of palms. The camellias grow throughout the understory while Spanish moss hangs from the dense branches.

In contrast, the Ravine Garden possesses the look and feel of the tropics with exotic growth of palm and banana trees, flowering vines, and such plants as bird of paradise and ginger. In

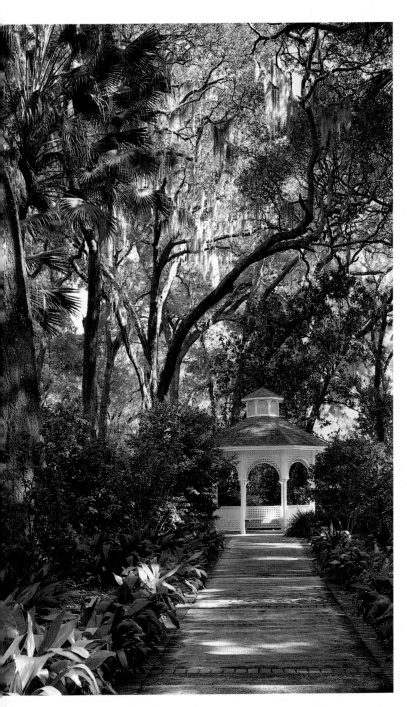

The gazebo is a favored architectural feature.

AT LEFT AND BELOW:
The Floral Clock.

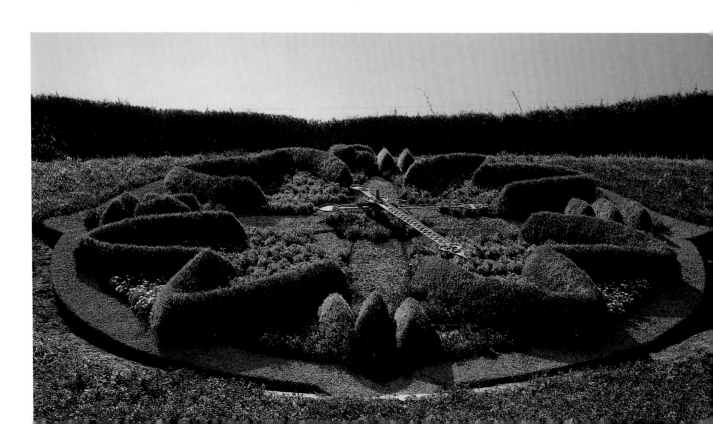

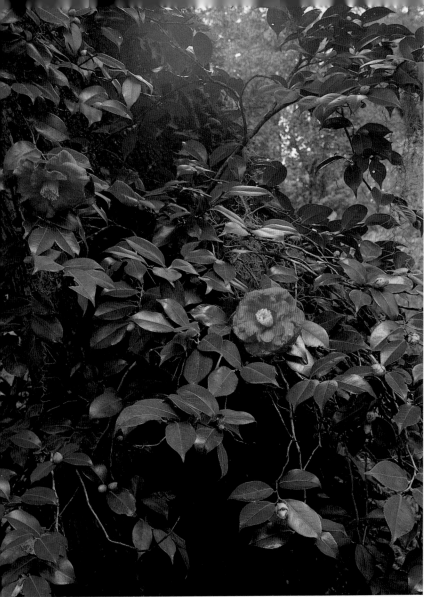

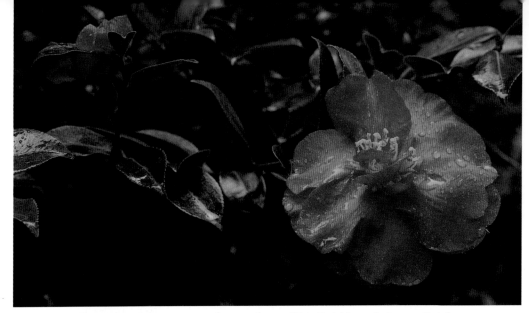

Examples of the over two thousand camellias that bloom between October and March.

starker contrast still is the xerophyte garden, which is designed to appear like a rocky, desert landscape.

Color is the dominant feature of the White Garden and of Mary Jane's Rose Garden. In the White Garden, shade-loving plants with white blooms as well as green and white variegated foliage flourish. The Rose Garden is the largest formal rose garden in the state of Florida, displaying over one thousand examples of the flower. A central fountain surrounded by four gazebos makes this setting a popular site for special events, particularly weddings.

Palms, cycads, and various bamboo cultivars flourish in the Palm Garden. Ferns, bromeliads, orchids, and other cold-sensitive tropical plants grow in the controlled climate of the garden's Conservatory. Ornamental and native wetland plants grow along the lakeshore, which can be viewed from the boardwalk and gazebo of the Wyckoff Overlook.

The two most unusual features of the Leu Garden are the fifty-foot-tall Floral Clock, imported from Scotland, and the Mizell Cemetery, where thirty-six members of the family that originally owned the land on which the garden is built are buried.

The Leu House, at the heart of the gardens, was built in the late 19th century as a two-story, five-room farmhouse by John Thomas Mizell, son of the original owners of the property. Its second owner, Duncan Clarkston Pell, added on to the house and planted an orange grove nearby. Its third owner, John H. Woodward, completed the house as its stands today.

CUMMER GARDEN

Jacksonville

As a young, turn-of-the-century bride, Nina May Holden Cummer was enthralled with the prospect of creating a formal European-style garden to complement the romantic, English Tudor-style house she and her new husband were building. Mrs. Cummer at first favored the plants she was familiar with in her native state of Indiana. But as she grew more experienced, she learned to cultivate plants that thrived in the Florida climate.

Nina Cummer's devotion to her garden was so contagious that the project eventually became an avocation for her husband Arthur as well. The couple's favorite gifts to one another were often garden sculptures, ornaments, or rare plant specimens, such as the Egyptian flower *agapanthus*, also known as Lilies of the Nile. The two pots of Lilies of the Nile that Mr. Cummer gave his wife nine decades ago have multiplied profusely over the years and today create a spectacular garden carpet of blue blossoms during the month of May.

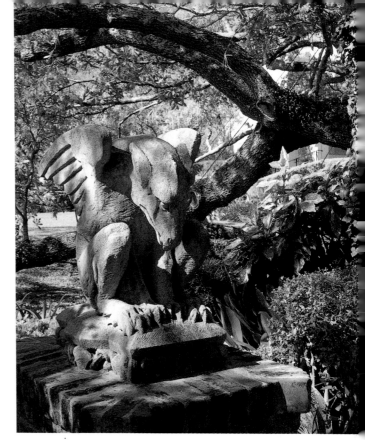

The Winged Gargoyle was rescued from a demolished building in New York City and presented to the garden in 1981.

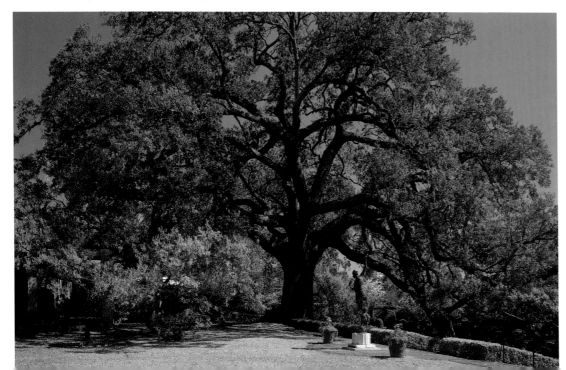

The 250-300-year-old oak, with a limb spread of over 150 feet. The sculpture is the goddess Diana of the Hunt.

103

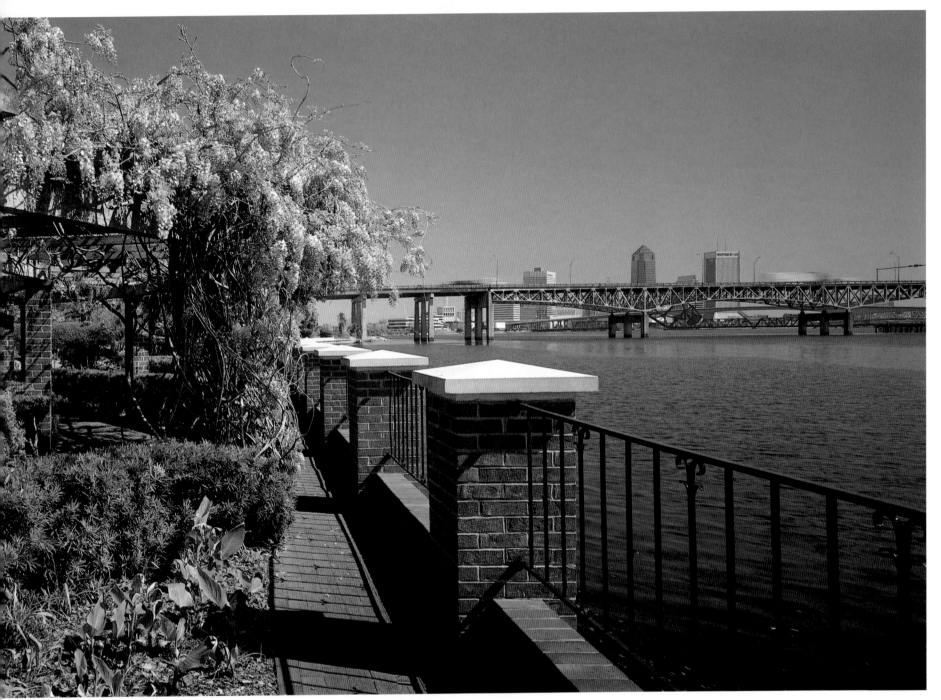
The garden overlooking downtown Jacksonville and the St. Johns River.

A view of the Italian Garden along the St. Johns River.

Nina Cummer founded the Garden Club of Florida, one of the first garden clubs in the nation. Today, the club, known as the Garden Club of Jacksonville, is the country's largest. In 1960, when the Cummers' house was demolished for the building of the present Cummer Museum of Art, the lovingly planted gardens, overlooking the St. Johns River, were preserved.

The Cummer Garden is composed of four sections: the Upper Garden through which one enters; the Center Garden, next to the Upper Garden; the Italian Garden, to the Center Garden's left; and the English Garden, to its right.

Besides the Lilies of the Nile, the Upper Garden is planted with flowering trees and plants as well as hedge and border plants that reinforce its formal, essentially symmetrical composition. Camellias, dogwoods, and hydrangeas add seasonal color, while podacarpus and mondo grass lend linear definition

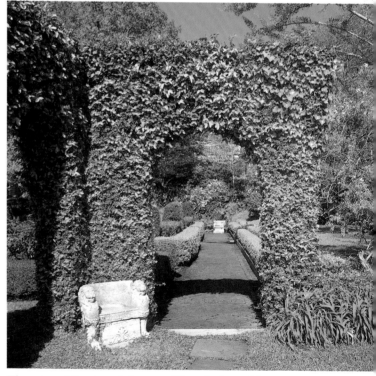

The winged lion bench imported from Italy and its reproduction are carved of stone.

105

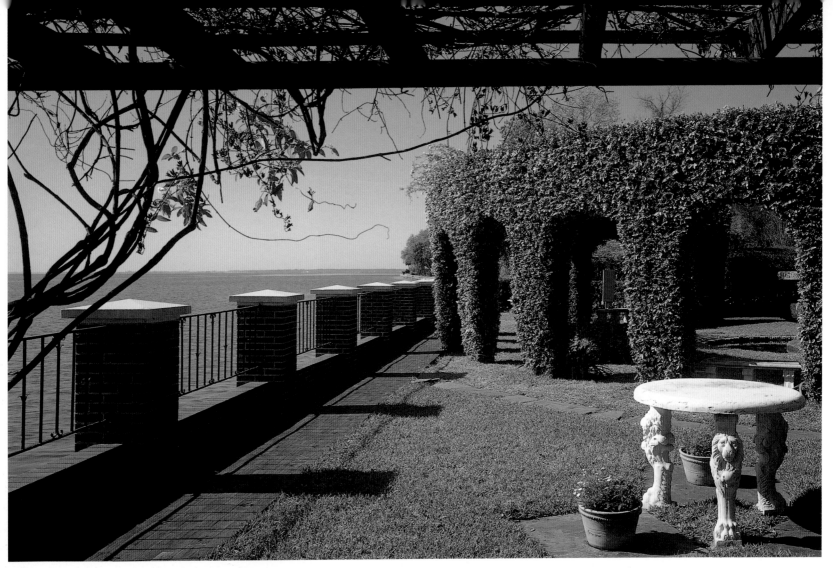

The wisteria arbor, at rear, was planted in 1910.

to the garden. Sited along the central axis in view of the Center Garden is a sculpture of the goddess Diana, donated by the artist Anna Hyatt Huntington to mark the opening of the Museum in 1960.

Designed around the first private putting green in Florida, a gift from Nina Cummer to her husband, the Center Garden has a spectacular view of the river and city skyline. Surrounding the green is a flowering border, planted each spring, of delphinium, snapdragons, petunias, pansies, and alyssum. The garden also hosts cleria, daylilies, agapanthus, hydrangea, bush daisies, thryallis, and bridal wreath. A pomegranate tree flourishes in the east corner.

The brick and flower lines walk of the museum.

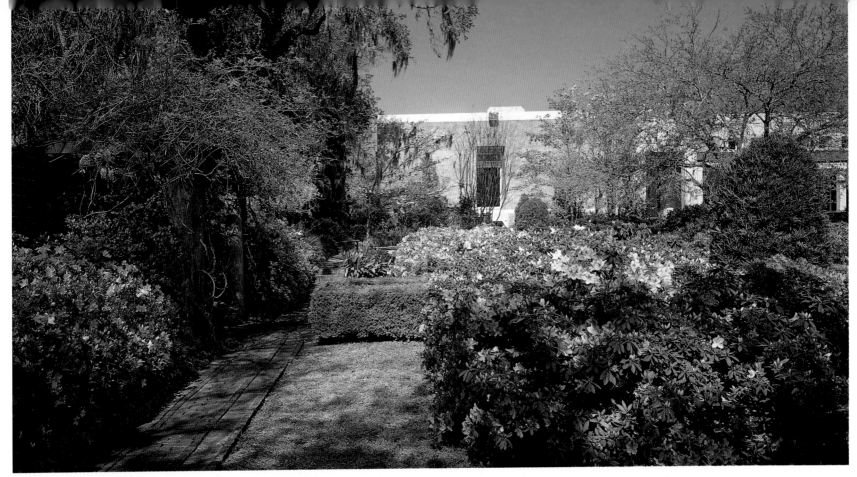

A profusion of azaleas in bloom.

The design of the Italian garden, which was inspired by a visit the Cummers made in 1930 to the gardens of Villa Gamberaia in Florence, is based on traditional 18th century Italian landscape design. Its central feature is the two reflecting pools in which Mrs. Cummer once kept Japanese fish. Carved stone garden furniture and ornaments, many decorated with the neoclassical lion's head motif, punctuate the garden's design. As in ancient Persia, where the beauty of a garden was determined by the sweetness of its fragrance (and its ability to attract nightingales), a jasmine arbor and rose garden perfume the air. Also planted here are daylilies, camellias, wisteria, dogwoods, calmondons, oriental maples, and redbud.

One of the most majestic features of the entire garden is the great, nearly 300-year-old oak tree that extends its limbs over 150 feet into the Italian, Center, and Upper Gardens.

The English Garden, created twenty years before the Italian Garden, is a showplace for azaleas. It was here, in the Tea Garden, that Mrs. Cummer entertained friends at afternoon gatherings. The mosaic fountain on the south wall enhanced the serenity of the setting with the sound of running water. At center is a mosaic-tiled pool bordered by a boxwood hedge and located symmetrically parallel to the twin reflecting pools in the Italian Garden. Along the waterfront side of the garden, a wisteria arbor invites the visitor to peaceful contemplation of the river.

ALFRED B. MACLAY
STATE GARDENS

Tallahassee

The Maclay house.

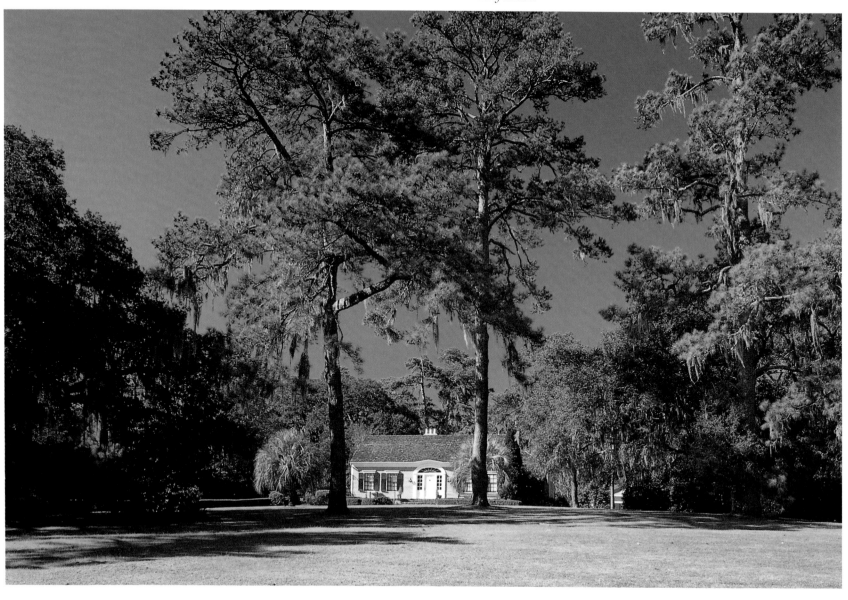

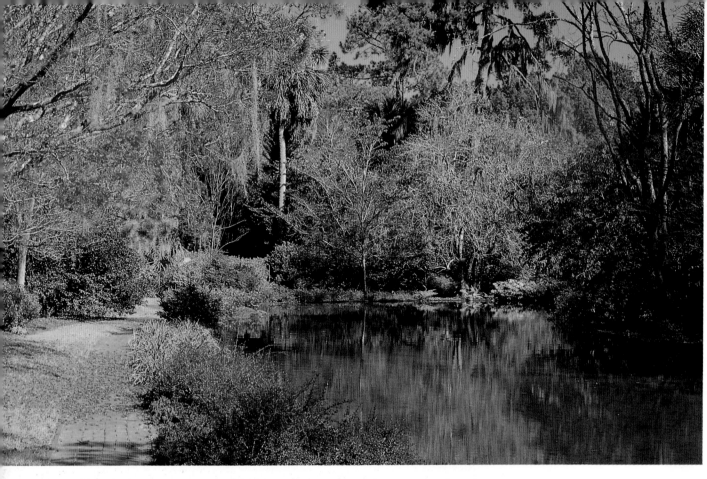

The Black Pond looking north with Japanese Red Maples in bloom and camellias on the banks.

When, in 1923, Alfred Barmore Maclay purchased the property that thirty years later would become Maclay State Gardens, there was only a narrow wagon trail from an unpaved road leading to a simple hunting lodge in the woods. The hundreds of acres of hills and forest, once a cotton and fruit tree plantation with sixty working slaves, would be cultivated into what is today a spectacular park with twenty-eight acres of ornamental gardens, including one of the largest collections of camellias and azaleas in the southeastern U.S.

Maclay was a wealthy New York banker and financier as well as a breeder of champion horses and dogs and a collector of early American furniture and glass. A passionate naturalist with a lifelong zeal for the literature of landscape design and

A memorial plaque.

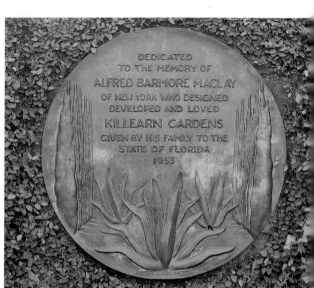

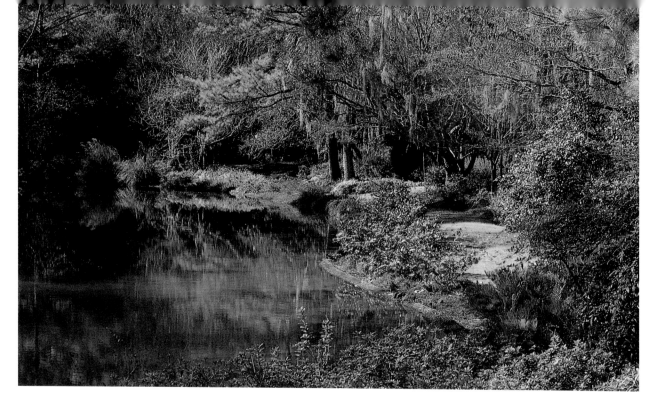

The Black Pond, looking south

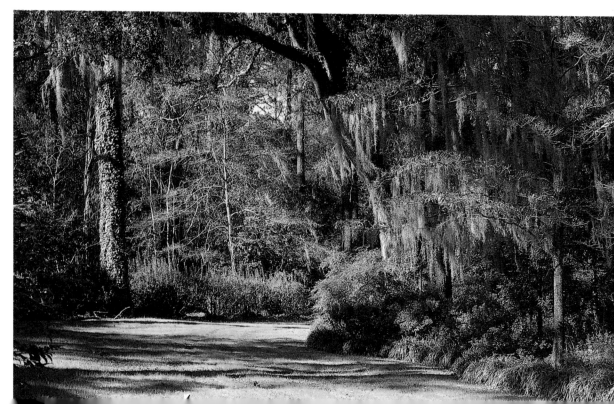

Eastern redbuds flower under oaks hung with Spanish moss.

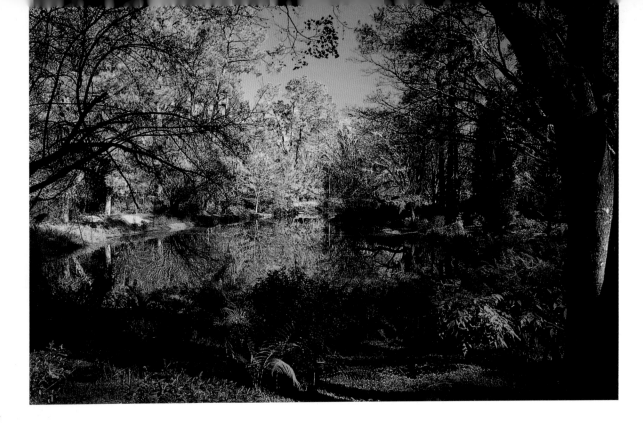

AT RIGHT:
The southern end of the Black Pond.

BELOW:
A Florida maple with Spanish moss at the shoreline of Lake Hall.

horticulture (he was at one time director of the American Horticultural Society), he was impressed with the huge oaks, pines, beautiful dogwoods, and hollies on this piece of land, which he chose for his winter home. He named the site Killearn Gardens, after the birthplace of his ancestors in Scotland.

On his travels throughout the U.S. and abroad, Maclay acquired numerous species of exotic plants. His botanical mission became the design of gardens which demonstrated that native and exotic plants could be used together to create exquisite settings. But rather than a "show garden" designed to excite the senses, he wanted a serene setting that would soothe the spirit. Maclay gave his plan a foundation of good "bones," i.e., trees and shrubs that provide a balance of shade, texture, and color year round. The peak blooming periods are winter and spring; in summer, a green-on-green effect enhances the sensation of coolness.

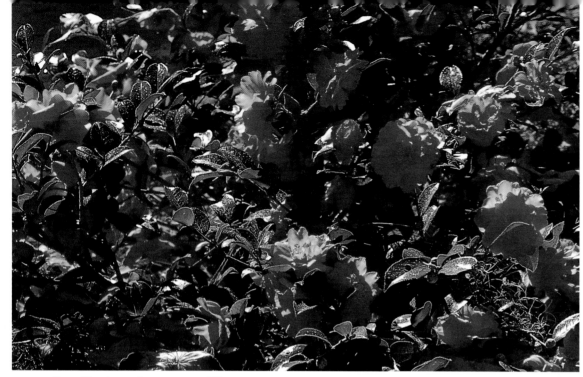

Camellias in various stages of bloom.

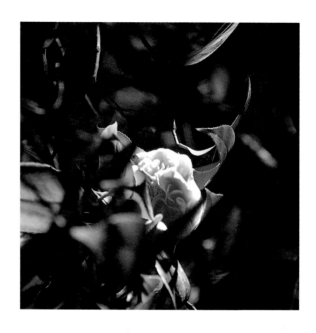

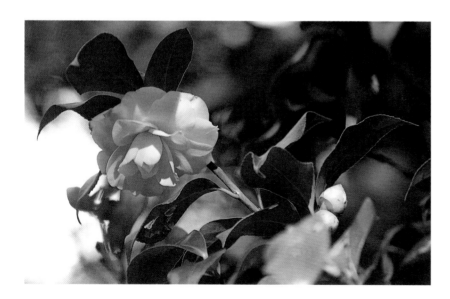

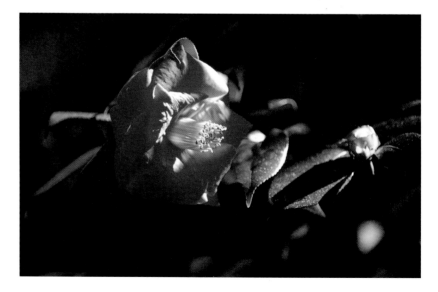

Pavilion overlooking Lake Hall.

AT RIGHT:
Examples of loblolly pines that grow throughout the garden.

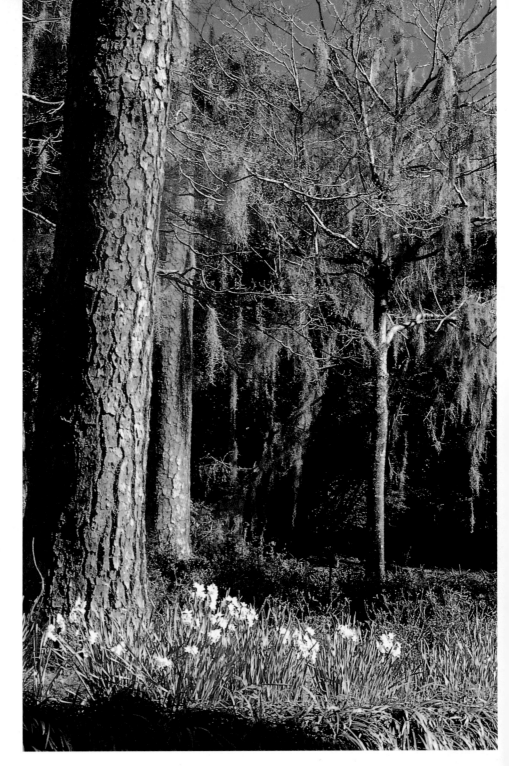

The garden wall, penetrated by a pattern of light and framed by a cascade of Spanish moss.

A view of Lake Hall framed by Sabal palmetto palms and cycads.

The featured plants of the garden are the camellias—150 different cultivars—which bloom from late fall through winter and into spring. Over sixty varieties of azaleas also bloom in winter and spring, along with the dogwoods, magnolias, cherry trees, and redbuds.

The gardens were developed in three stages. The first were the formal areas, including the Walled Garden and the Camellia Way. The Walled Garden was inspired, in part, by Maclay's travels and his studies of the culture and flora of Europe. It evokes the look of European monastery walled gardens and the feel of classical Renaissance design, especially with the polychrome plaque, a replica of one by della Robbia. The exhibition of trees around a walkway was a popular garden fashion in the 1920s. Among the camellias here is the first planted in this garden and the first brought to Tallahassee.

The walled garden with della-Robbia-style plaque,
brick pattern design, and reflecting pool.

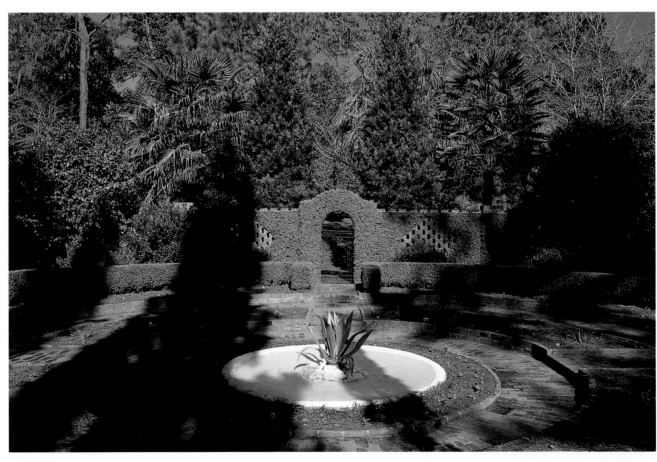

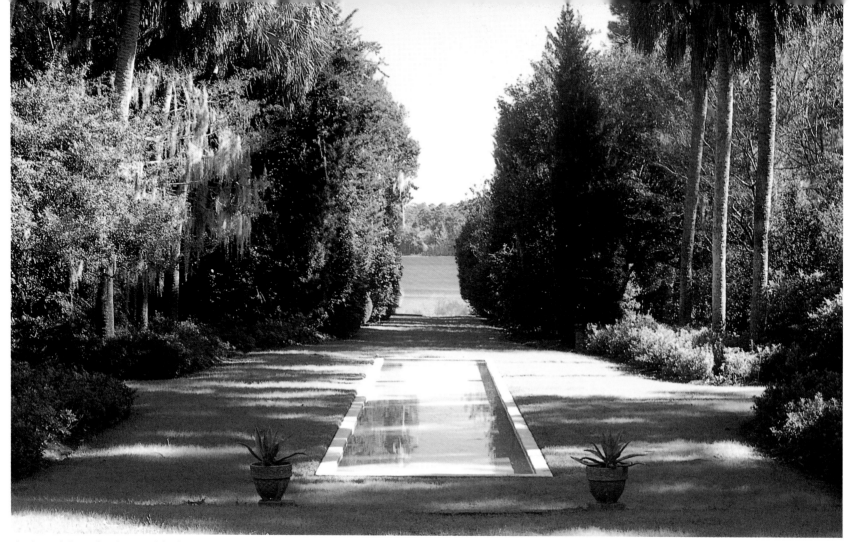

A view of the reflecting pool looking toward Lake Hall.

The Reflection Pool derives from the Italian reflecting pools of the Renaissance and represents the second stage of Maclay's overall plan. It is flanked on both sides by Sabal palms, the state tree of Florida, and is sited so that the visitor discovers it as a surprise, another garden device popular in the 1920s.

The final section to evolve under Maclay's direction was the Azalea Hillside, which takes its naturalistic look from the carefully planned but informally arranged plantings of the 19th century English-style gardens. The Pond below was built to reflect the hillside's colors as well as those of its surrounding plantings.

After Alfred Maclay's death in 1944, his wife Louise carried on his mission. Eventually, she opened the gardens to the public (they were renamed in her husband's honor) and donated 307 acres to the Florida Park Service, which later developed a 17-acre recreation area on Lake Hall. The remaining property has been left as natural woodlands.

ADDITIONAL FLORIDA GARDENS AND PRESERVES

Museum of Natural History of the Florida Keys
Marathon, Mile Marker 50
Over sixty acres featuring ten endangered plants

Lignumvitae Key State Botanical Site
Islamorada, (305) 664-9814
A tropical hammock reached only by boat

Blowing Rocks Preserve
Tequesta, (561) 747-3113, 575-2297
Take I-95 or Florida Turnpike to Jupiter exit. Go east to U.S. 1. Turn left (north) to Alternate AIA (Beach Road). Turn right over the bridge to Jupiter Island. Go north two and a half miles. Sign appears on right. High tide is the best time to visit.
Restored dunes and landscaped garden

Sunken Gardens
St. Petersburg, 1825 Fourth Street, North, (813) 896-3186
Planted in a sinkhole, with tropical plants and birds

Mead Gardens
Winter Park, at South Denning Drive and Garden Drive, (407) 623-3342
Fifty-five acres with lakes and orchid greenhouse

AT LEFT:
Pandanus or screw pine with bottle palm at right.

Heathcote Botanical Gardens
Fort Pierce, 210 Savannah Road, (561) 464-4672
Formerly a nursery, the gardens have a palm collection, herb garden, orchid house, native plant demonstration bed, larger perennial border, and large bulb collection.

Sugar Mills Garden
Near Vero Beach, 950 Old Sugar Mill Road, (904) 767-1735
Originally a 1930s amusement park with concrete dinosaurs still standing; a pioneer settler's garden, 100 species of ivy, library

McKee Botanical Gardens
Vero Beach, (561) 234-1949
Under restoration, to open in 1998

Ravine State Gardens
Palataka, on Route 20, (904) 329-3721
Developed in 1933 by the federal WPA, includes palms and azaleas

Paynes Prairie
McIntosh, on U.S. 441, between Gainesville and Ocala, (352) 466-3397
A 20,000-acre preserve of marsh, prairie, pines, and hammock

Kanapaha Botanical Gardens
Gainesville, 4625 SW 63 Blvd., off State Road 24, one mile west of I-75, (352) 372-4981
Sixty-two acres including herbs, bamboo, rock garden

Torreya State Park
Bristol, (904) 643-2674
Take I-10 to Exit 25 (Hwy. 12), Greensboro. Then go north on County Road 1641 for eight miles.
Includes a floodplain forest and ravines

Eden State Gardens
Point Washington, (904) 231-4214
On U.S. 98 between Panama City and Fort Walton Beach. Take County Road 395 north to Point Washington and follow the signs.
An 1895 plantation home and gardens

A CALENDAR OF FLORIDA GARDEN EVENTS

JANUARY

Arbor Day Festival
Flamingo Gardens
Davie/Ft. Lauderdale (954) 473-2955

Annual Redland Natural Arts Festival
Fruit and Spice Park
The Redland (305) 247-5727

House & Garden Tours
Key West (305) 294-9501

Rose Show & Sale
Fairchild Tropical Garden
Miami (305) 667-1651

National Camellia Convention
Leu Botanical Gardens
Orlando (407) 246-2620

Annual Picnic and Plant Sale
University of Miami Gifford Arboretum
Miami (305) 284-5364

FEBRUARY

House & Garden Tours
Key West (305) 294-9501

Datura, a kind of trumpet plant.

International Carillon Festival
Bok Tower Gardens
Lake Wales (813) 676-1408

Orchid Society Show & Sale
Fairchild Tropical Garden
Miami (305) 667-1651

Winter Plant Sale
Mounts Botanical Garden
West Palm Beach (407) 233-1749

MARCH

Annual Spring Flower Festival
Cypress Gardens
Winter Haven (800) 282-2123 in FL; (941) 324-2111

121

Spring Plant Sale
Leu Botanical Gardens
Orlando (407) 246-2620

Citrus Plant Sale
Flamingo Gardens
Davie/Ft. Lauderdale (305) 473-2955

Palm Beach Spring Antiques & Garden Show
West Palm Beach (407) 483-4047

Asian Arts Festival
Fruit and Spice Park
The Redland (305) 247-5727

House & Garden Tours
Key West (305) 294-9501

South Florida Orchid Society Show
Miami/Coconut Grove (305) 255-3656

Sarasota Ikebana Society Exhibition
Spring Plant Fair & Orchid Auction
The Marie Selby Botanical Gardens
Sarasota (813) 366-5731

Azalea Festival
Palatka (904) 328-1503

Annual Garden Tour
Alfred B. Maclay State Gardens
Tallahassee (904) 487-4115

APRIL

Orchid Show & Sale
Flamingo Gardens
Davie/Ft. Lauderdale (305) 473-2955

Epcot International Flower & Garden Festival
Lake Buena Vista (407) 824-4321

Bonsai Society Show & Sale
Spring Plant Sale
Metropolitan Miami Flower Show
Miami (305) 667-1651

Orchid Ball
Easter Celebration
Sarasota Bromeliad Society Show & Sale
The Marie Selby Botanical Gardens
Sarasota (813) 366-5731

Herbal Fantasy
Mounts Botanical Garden
West Palm Beach (407) 233-1749

MAY

Annual Plant & Cycad Show & Sale
Flamingo Gardens
Davie/Ft.Lauderdale (305) 473-2955

Plant Sale
Mounts Botanical Garden
West Palm Beach (407) 233-1749

Spring Moon Stroll
Leu Botanical Gardens
Orlando (407) 246-2620

Annual Bloom Festival and Open House
Alachua (905) 462-1539

Epcot International Flower & Garden Festival
Lake Buena Vista (407) 824-4321

Flowering Tree Show & Sale
Bromeliad Show & Sale
Cactus & Succulent Show & Sale
Fairchild Tropical Garden
Miami (305) 667-1651

American Hibiscus Show
Punta Gorda (941) 966-2658

Sarasota Show-fu Bonsai Society Show & Sale
Mother's Day Garden Tour
The Marie Selby Botanical Gardens
Sarasota (813) 366-5731

JUNE

American Hibiscus Society Show
Ft. Myers 941/466-5965

Bamboo Show & Sale
Fern Show & Sale
Fairchild Tropical Garden
Miami (305) 667-1651

Heliconia.

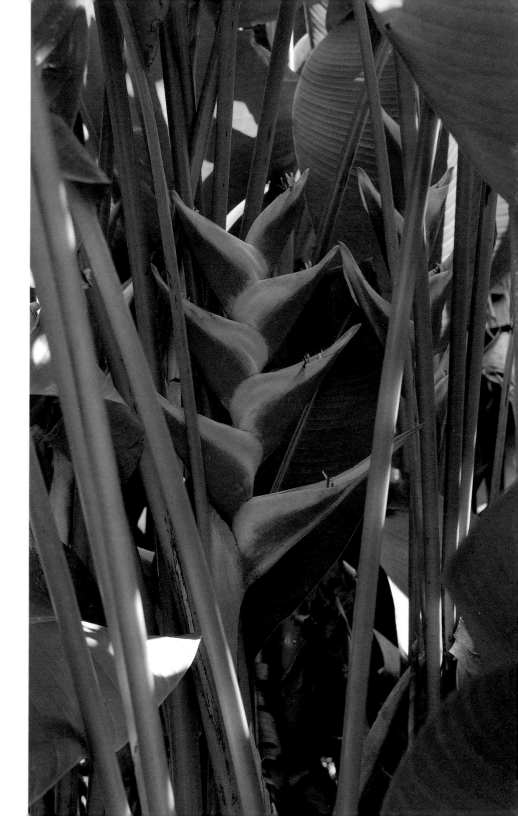

Royal Poinciana Festival
Miami (305) 661-2481

Victorian Garden Party
Cypress Gardens
Winter Haven (800) 282-2123 in FL

JULY

Garden Sale and Flea Market
Heathcote Botanical Gardens
Ft. Pierce (407) 464-4672

Tropical Agriculture Fiesta
Fruit and Spice Park
The Redland (305) 247-5727

AUGUST

Heliconia Show & Sale
Fairchild Tropical Gardens
Miami (305) 667-1651

American Hibiscus Show
Port Richey (813) 856-7363

American Hibiscus Society Show
Venice (941) 426-7458

SEPTEMBER

American Hibiscus Society Show
Bradenton (941) 746-6616

Aroid Show & Sale
Fairchild Tropical Garden
Miami (305) 667-1651

Fall Palm Sale
Flamingo Gardens
Davie/Ft. Lauderdale (954) 473-2955

American Hibiscus Society Show
St. Petersburg (813) 391-7503

OCTOBER

Harvest Moon Stroll
Heathcote Botanical Gardens
Ft. Pierce (407) 464-4672

Harvest Moon Stroll
Leu Botanical Gardens
Orlando (407) 246-2620

Plant Affair West: Outdoor Garden Plant Show
Flamingo Gardens
Davie/ Ft. Lauderdale (305) 473-2955

Hibiscus Show & Sale
Fairchild Tropical Garden
Miami (305) 667-1651

Moonlight Stroll
Alfred B. Maclay State Gardens
Tallahassee (904) 487-4115

American Hibiscus Society Show
Vero Beach (407) 231-2133
West Palm Beach (407) 968-0959

Royal poinciana.

NOVEMBER

American Hibiscus Society Show
North Miami (305) 981-6737

Annual Mum Festival
Cypress Gardens
Winter Haven (800) 282-2123 in FL; (941) 324-2111

Founder's Day
Flamingo Gardens
Davie/Ft. Lauderdale (954) 473-2955

Poinsetta Festival & Garden of Lights
Cypress Gardens
Winter Haven (800) 282-2123 in FL; (941) 324-2111

West Palm Beach Garden Club Annual Bazaar
West Palm Beach (407) 833-3514

Annual Garden Festival
Heathcote Botanical Gardens
Ft. Pierce (407) 464-4672

Palm Show & Sale
Fairchild Tropical Garden
Miami (305) 667-1651

Fall Garden Fair
Leu Botanical Gardens
Orlando (407) 246-2620

The Ramble: Holiday Gardening & Horticultural Festival
Fairchild Tropical Garden
Miami (305) 667-1651

Holiday Week
Leu Botanical Gardens
Orlando (407) 246-2620

VISITING THE GARDENS

Bok Tower Gardens
Near the crossroads of U.S. Hwy. 27 and S.R. Hwy 60, three miles north of Lake Wales off County Road 17A (Burns Ave.), (941) 676-9412
Open daily 8:00 A.M.-5:00 P.M.
Admission: adults: $4.00; children 5-12: $1.00
Facilities: garden café, picnic area, rest rooms, visitor center, walking paths, wheelchairs and strollers available free, pet facility free

Bonnet House
900 North Birch Road, Ft. Lauderdale, (954) 563-5393
Bonnet House can be viewed by reservation only during guided tours at 10 A.M. and 1:30 P.M. Tuesdays, Thursdays, and Sundays.
Admission: adults: $7.50; seniors: $5.00; children under 6: free
Facilities: the house, its gardens, Frederic Clay Bartlett's painting studio, a gallery of Evelyn Bartlett's paintings

Busch Gardens
Busch Blvd. and 40th Street, Tampa, (813) 987-5000
Open daily from 9:30 A.M. to 6 P.M., except during summer and holiday periods when hours are extended.
Admission: adults: $33.95 plus tax; children: $27.95 plus tax for ages 3-9; children under 2: free. Admission includes access to all rides, shows, and most park attractions. Year passes are available.
Facilities: restaurants, shops, displays, rides, eight theme areas, live entertainment, wheelchairs, strollers

Caribbean Gardens
1590 Goodlette-Frank Road, Naples, (941) 262-5409
Open daily 9:30 A.M.-5:30 P.M.
Admission (which includes all activities): adults: $12.95; children 4 to 15: $7.95

Coral Gables' Venetian Pool
2701 Desoto Blvd., Coral Gables, (305) 460-5356
Open Monday-Friday from 11 A.M. to 7:30 P.M.; Saturday and Sunday from 10 A.M. to 4:30 P.M. Closed Mondays during winter.
Admission: adults: $4; children 3-12: $1.60; 13-17: $3.50
Facilities: snack bar, wheelchair accessibility

Cummer Museum of Art and Garden
829 Riverside Avenue, Jacksonville 32204, (904) 356-6857
Open Tuesday, Thursday 10 A.M.-4 P.M.; Wednesday, Friday, and Saturday, 10 A.M.-5 P.M.
Admission: adults: $5.00; students: $3.00; seniors and military: $3.00; children under 5: free; Tuesdays, 4 P.M.-9:30 P.M.: Free
Facilities: museum, gift shop, free wheelchairs

Cypress Gardens
Off U.S. Hwy. 27 at S.R. 540, Winter Haven, (800) 282-2123, (941) 324-2111
Open daily 9:30 A.M.-5:30 P.M.
Admission: adults: $27.95; children 6-12: $17.95; senior/AARP: $22.95
Facilities: full-service dining room, walk-up stands, ice cream parlors, bakery, fudge shop, ten boutiques, wheelchairs (nominal fee), pet facility (for nominal fee)

Edison-Ford Winter Estates
2350 McGregor Blvd., Ft. Myers 33901, (941) 334-3614 [Groups: (941) 334-7419]
Open daily except Thanksgiving and Christmas, Monday-Saturday 9 A.M.-4 P.M.; Sunday 12-4 P.M.
Admission: adults: $10; children 6-12: $5
Facilities: historic homes, research laboratory, museum

Fairchild Tropical Garden
10901 Old Cutler Road, Miami 33156, (305) 667-1651
Open daily except Christmas 9:30 A.M.-4:30 P.M.
Admission: adults: $8.00; children under 13: free.
Facilities: garden café, bookstore, exhibition hall, rare plant house, free tram tours, wheelchairs

Flamingo Gardens
3750 Flamingo Road, Davie/Ft. Lauderdale, (954) 473-2955
Open daily (except between June 1 and October 31, when it is closed Mondays) from 10 A.M. to 6 P.M.
Admission: adults: $8.00; children 3-9: $4.50
Facilities: grill, gift shop, garden shop, playground, classrooms, barbeque house

Harry P. Leu Gardens
1920 N. Forest Ave., Orlando 32803-1537, (407) 246-2620
Open daily 9 A.M.-5 P.M.; Leu House Museum open Tuesday-Saturday 10 A.M.-3 P.M., Sunday and Monday 1-3 P.M.
Admission: adults: $3; children 6-16: $1
Facilities: the Garden House Educational and Multipurpose Building with library, exhibition space, classrooms, and conference and special events space; Garden Shop offering books and gifts. Wheelchairs available free.
Guided tours of ten or more persons must be booked three weeks in advance.

Alfred B. Maclay State Gardens
3540 Thomasville Road, Tallahassee, (904) 487-9910
Gardens open 9 A.M. to 5 P.M., daily, January 1 to April 30; Park open 8 A.M. to sunset, daily; Maclay House open 9 A.M. to 5 P.M., daily, January 1 to April 30

Admission: adults: $3.00; children: $1.50
Facilities: Twenty-eight acres of ornamental gardens; seventeen acres of recreation area on Lake Hall with picnicking, swimming, fishing, non-gasoline boating, and two nature trails. Lake Overstreet Addition offers five and a half miles of trails for hiking, biking, and horseback riding. State Range Station: (904) 487-4556.

Morikami Museum and Japanese Garden
4000 Morikami Park Road, Delray Beach, (407) 495-0233
Open Tuesday-Sunday from 10 A.M. to 5 P.M.
Admission: adults: $4.25; seniors: $3.75; children 6-18 and college students: $2.00
Facilities: library, museum store, café

Mounts Botanical Garden
531 N. Military Trail, West Palm Beach 33415, (561) 233-1749
Open Monday-Saturday 8:30 A.M.-4:30 P.M.; Sunday 1:00-5:00 P.M.; holidays 1:00-5:00 P.M.
Free admission
Free tours for groups of ten or more, available by reservation on weekdays.
Free guided tours for general public on Saturday at 11 A.M.; Sunday at 2:30 P.M.

Parrot Jungle and Gardens
1100 SW 57th Avenue, Miami, (305) 666-7834
Open daily 9:30 A.M.-6:00 P.M.
Admission: adults: $11.95; children 3-10: $7.95; seniors: $10.95
Facilities: café, gift shop, wheelchairs, strollers

Marie Selby Botanical Gardens
811 South Palm Avenue, Sarasota 34236, (941) 366-5731
Open daily except Christmas from 10 A.M. to 5 P.M.
Admission: adults: $7; children 6 to 11: $3
Wheelchairs available
Facilities: gift and bookshop, plant shop.

Slocum Water Gardens
1101 Cypress Gardens Blvd., Winter Haven 33884,
(941) 293-7151
Open Monday-Friday from 8 A.M. to 5 P.M.; Saturday from 8 A.M.
to 12 noon
Free admission

The Society of the Four Arts
2 Four Arts Plaza, Palm Beach, (561) 655-7227
Museum and garden open Monday-Saturday, 10 A.M.-5 P.M.;
Sunday 2 P.M.-5 P.M. December through March.
Library open all year, daily except Sunday.
Free admission to garden and museum

Vizcaya
3251 South Miami Ave., Miami, (305) 250-9133
Open daily 9:30 A.M. to 4:30 P.M. (ticket sales close)
Admission: general public: $10; seniors: $8; children 6-12: $5.
Facilities: café, bookstore, and giftshop

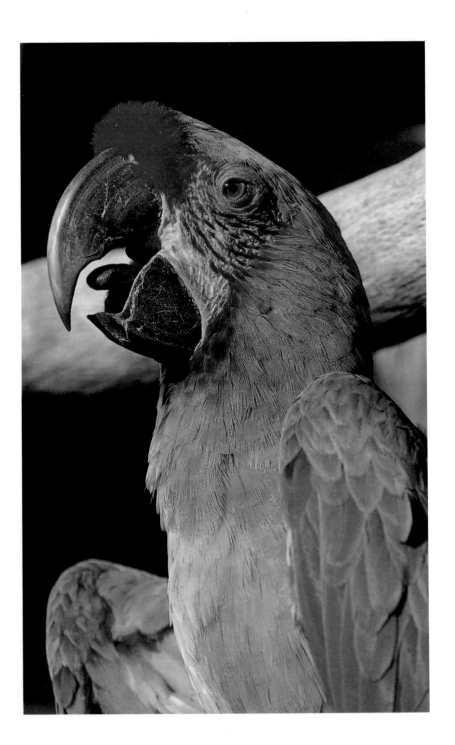